THE CHAW

GW01191177

A FOURTEENTH-CENTURY GENEALOGY OF THE KINGS OF ENGLAND

A FOURTEENTH-CENTURY GENEALOGY OF THE KINGS OF ENGLAND

THE CHAWORTH ROLL

A FOURTEENTH-CENTURY GENEALOGY OF THE KINGS OF ENGLAND

Alixe Bovey

Sam Fogg
15D Clifford Street
London, W1S 4JZ

TEL	020 7534 2100
FAX	020 7534 2122
EMAIL	info@samfogg.com
WEBSITE	www.samfogg.com

ACKNOWLEDGEMENTS

It gives me great pleasure to thank the individuals and institutions from whose assistance I have benefited while preparing this publication. With their customary generosity and forbearance, the staff of the Cambridge University Library, the British Library, the Bodleian, and the Courtauld Institute's Conway Library made the collections in their care available. I have profited from access to unpublished material, including the report drawn up by the late Jeremy Griffiths when the Chaworth Roll was first sold in 1988; Olivier de Laborderie's heretofore unpublished transcription (sections of which appear here, together with a translation by Marigold Anne Norbye); and A. S. G. Edwards' forthcoming article on Notre Dame MS 67. I am indebted to A. S. G. Edwards, John A. A. Goodall, Olivier de Laborderie, John Lowden, and Will Noel for their advice and characteristically incisive comments. Marigold Norbye, Arcadia Fletcher, Annick Lapôtre and Sam Fogg guided this publication through its final, crucial stages when circumstances meant that I could not. For this and much else I owe them especially heartfelt thanks. The errors of fact and interpretation that inevitably remain are entirely my own.

AB
25 January 2005

This book accompanies an exhibition
of the Chaworth Roll at
Sam Fogg,
15d Clifford Street,
London
between 3-24 March 2005.

FRONT COVER
Edward I (1272-1307)

BACK COVER
Genealogy of Danish kings of England
from Knut (1016-1035) to Harold I
'Harefoot' (1035-1040)

FRONTISPIECE
Wheel of Fortune

CONTENTS

A NOTE ON CONVENTIONS

Unless otherwise specified, all images are of the Chaworth Roll.

Dates in parentheses refer to regnal dates, unless noted otherwise.
Birth and death dates are noted with the abbreviations b. = born, d. = died.

Quotations from the Chaworth Roll are taken from Marigold Anne Norbye's
translation, reproduced here alongside Olivier de Laborderie's transcription.

THE DISCOVERY AND REDISCOVERY OF THE CHAWORTH ROLL

On 5 February 1885, E. W. Godwin Esq. 'exhibited a very curious Genealogical Roll of the Kings of England' to the fellows of the Society of Antiquaries in London. It belonged, he explained, to Mrs Chaworth Musters, and was written during the reign of Edward II with a continuation added during the reign of Henry IV. He reported that it was 'preserved in the Chaworth family together with a family pedigree' and asserted that it had probably been 'made for Maud de Chaworth, who married Henry of Monmouth, afterwards Earl of Lancaster.'[1] Godwin gave some indication of the art-historical importance of the roll, commenting that its 'chief point of interest is the artistic excellence of some of the figures, which are drawn in outline and slightly tinted. The large figure of Dame Fortune at the head of the roll is especially well-designed [...]' [see frontispiece]. Godwin's presentation, a short notice of which was published in the *Proceedings of the Society of Antiquaries* for 1885, was the last that was heard of this genealogical roll until it was sold by the Chaworth Musters family in 1988.[2]

Godwin's comments about the 'artistic excellence' of the Chaworth Roll's drawings were a tantalizing clue to its art-historical significance. The technique and style of the Chaworth Roll's drawings are immediately recognizable as the work of an artist in the circle of the Queen Mary Master, the anonymous illuminator responsible for the eponymous Psalter in the British Library (Royal MS 2 B VII). The Queen Mary Master was prolific and influential in the 1310s and '20s, his graceful, delicate style attracting the patronage of royalty and aristocrats and influencing a generation of artists around him [figs. 2 and 4]. While the style of the Chaworth Roll's drawings ties it to the work of the Queen Mary Master, its technique links it to an established English tradition of tinted drawings. This technique links the roll to twelfth- and thirteenth-century genealogies, and more broadly to an indigenous style that flourished in England before the conquest. In contrast to historical chronicles and genealogies made in the twelfth- and thirteenth-centuries that were made primarily by and for monks, the Chaworth Roll was commissioned by a lay patron. In this respect it reflects the development of a lay readership who wanted to read – and to own – an accessible overview of their country's history. Thus, the Chaworth Roll is a material witness to the growth of a new audience for English history in the later Middle Ages.

The present study considers the style, content, patronage and purpose of the Chaworth Roll. Tracing the roll's history from its creation by two artists, dubbed here the Chaworth Master and the Chaworth Assistant, I will suggest that it was made between 1321-1327, and explore its close relationship to three other genealogical rolls, now in the Bodleian (Oxford, Bodleian MS Fr. d.1 (R)) and Cambridge University Library (Cambridge, University Library MS Oo.7.32 and MS Dd.3.58). Following a reconsideration of the genealogy of the Chaworth family itself, I will argue that the roll was commissioned not by Maud de Chaworth, as Godwin and others have suggested, but by a distant cousin, Sir Thomas Chaworth, and that one of his descendants, another Thomas, was responsible for the continuation added between 1399-1413.

FORM AND CONTENT

The Chaworth Roll is approximately 24.5 cm wide and 6.5 meters long, and consists of nine parchment membranes glued end to end. The first eight of these membranes were assembled and executed (as will be argued in detail below) between 1321-7. The roll begins with three large roundels representing, in turn, the Roman Roads of Britain, a Wheel of Fortune, and the seven Anglo-Saxon kingdoms, known as the Heptarchy [fig. 31]. The Heptarchy diagram is followed by a passage explaining its content (transcribed and translated below, p. 37). The royal pedigree then begins with King Egbert [fig. 1], and continues to Edward II and his four children. A ninth membrane was added to the roll during the reign of Henry IV, between 1399-1413, which continues the genealogy from Edward III to Henry IV's children.

The backbone of the genealogy is the representation of the Kings of England and their children in medallions interconnected with green bands. Large medallions containing fictive portraits of the kings are arranged along a central axis, with smaller medallions containing images of each monarch's children. Kings themselves are depicted twice, first among their siblings as their fathers' sons, and again in larger roundels as crowned monarchs. Only the depiction of Edward I's children deviates from this circle-and-line pattern: these portraits

are represented in a quasi-architectural arcade of niches [figs. 14 and 15]. A single artist, dubbed here the Chaworth Master, executed all of the drawings on the first eight membranes of the roll, except for six portrait roundels and eight of the children of Edward I portrayed in niches on the eighth membrane. We will examine the division of labour between these two artists in due course (p. 22).

All of the portrait medallions contain full-length figures seated on benches. The kings are crowned, and hold swords, scepters, or both. Most of the kings face forward, confronting the viewer directly, while their children usually turn to face one another in pairs, gesturing towards one another conversationally. These pen-and-ink portraits are subtly washed with colour, the drapery of their clothes tinted with pale green and red. Backgrounds are painted in solid washes of either red or blue or, occasionally, left as bare parchment. The compass-drawn roundels and the bands that connect them are washed with a bold green.

Passages written in Anglo-Norman French accompany the circle-and-line pedigree, summarizing the main features of each monarch's tenure, including the duration of the reign and the place of the king's burial. A single scribe is responsible for the text on the first seven membranes of the roll, including the inscriptions that identify each portrait, in a clear Gothic book-hand.[3] Two additional scribal hands added texts to the penultimate membrane. The content of these passages is discussed below (pp. 28-31), and excerpts from the roll are transcribed and translated (p. 37).

Modern repairs have patched the parchment where it has been damaged by the corrosive action of the verdigris green pigment used liberally in the genealogy. The surface of the parchment is rubbed, testimony to the wear and tear of repeated unfurling and re-rolling of the manuscript over seven centuries. Overall, the Chaworth Roll is in very good physical condition.

Fig. 1
Egbert (802-839)
and Beorhtric

THE QUEEN MARY MASTER STYLE

The fine tinted drawings of the Chaworth Roll are close to the style and technique of the celebrated Queen Mary Master, so-called after the Queen Mary Psalter in the British Library [fig. 2].[4] The Queen Mary Psalter, made c. 1320, stands out as one of the most remarkable English manuscripts of its generation.[5] Its extensive pictorial program was executed in two techniques. The miniatures and historiated initials in the calendar and Psalter are painted in opaque colours touched with gold, while the Old Testament prefatory cycle, consisting of some 223 images between ff. 1v-66v, and the hundreds of *bas de page* scenes between ff. 85v-318r are delicate drawings tinted with transparent washes of colour. It is to the Queen Mary Master's tinted drawings that the Chaworth Roll's drawings are most closely related.

In addition to decorating the Psalter, the Queen Mary Master was the sole illuminator of at least three further manuscripts, and collaborated with other artists on several more.[6] In her contribution to the *Survey of Manuscripts Illuminated in the British Isles*, Lucy Sandler wrote 'This style is immediately recognizable for delicate, precise, yet free linearity, for slender, tall figures, swaying poses, elegant gestures and articulated facial features, [and] a preference for tinted rather than body colour in figures.'[7] According to Sandler, 'About twenty manuscripts (or sections of manuscripts) fulfil these criteria of style.'[8] The tinted drawings of the Chaworth Roll, unknown to Sandler at the time of the publication of her Survey volume in 1986, live up to her characterisation of the Queen Mary style.

Fig. 2
Queen Mary Psalter: God as creator of the universe and the fall of Lucifer. British Library, Royal MS 2 B VII, f. 1v

Coment lucifer chayt de ael e deuient diable. e git multitudo des angeles

Despite the obvious affinity of style and technique between the Queen Mary Master and the Chaworth Master, one can only speculate about the nature of the relationship between these two artists. No documents survive which point to the identity of either of these anonymous masters. The little that is known about the career of the Queen Mary Master is the result of the painstaking analysis of the quality, style, patronage, and content, both iconographic and textual, of surviving manuscripts. While attributions have been made to a Queen Mary Master 'workshop', nothing is known about the form such a workshop might have taken: was it a physical space, or does it describe a perceived pattern of collaboration between illuminators? Did the Master train apprentices, and if so, might the Chaworth Master and other practitioners of the 'Queen Mary style' have been his understudies? These questions are symptomatic of a wider gap in our knowledge about where and how illuminators collaborated in the later Middle Ages. Writing about fifteenth-century illuminators, Jonathan Alexander revealed the extent of this problem when he asked 'what is meant by "associates", or "workshop", or "school", or "atelier"? [...] Are the "assistants" actual apprentices, or past apprentices?'[9]

The complexity of the problems relating specifically to the Queen Mary Master's career and collaborations has been revealed in two articles by Lynda Dennison. Dennison argued that the Queen Mary Master worked with an artist dubbed the Ancient 6 Master on and off between 1310-35, characterizing their collaboration as the 'central Queen Mary Workshop.'[10] She then explored another group of manuscripts related to the Queen Mary style, calling its chief artistic personality the Subsidiary Queen Mary Artist.[11] Dennison's research has shown that the Queen Mary Master collaborated with several other artists over a long period, and furthermore, that illuminators with whom he seems not to have collaborated directly nevertheless picked up and developed his style. She also confirmed that the central Queen Mary workshop was located in London.[12]

In style, technique, and iconography, the Chaworth Master's work is related to the Queen Mary Master's tinted drawings. The iconographic kinship of the Chaworth Master with the Queen Mary Master is evident in a comparison, for example, of the Chaworth Master's portraits of kings Edred (946-955) and Edwy (955-959) [fig. 3] with the Queen Mary Master's Pharaoh from the Psalter's prefatory cycle [fig. 4]. Both wear tunics with cloaks clasped at the throat, and crowns with three fleur-de-lis. Their hair is scraped back at the forehead, and curls upwards at the nape of the neck. The Chaworth Master's hands, like the Queen Mary Master's, have long, elegant fingers [fig. 5]. It is impossible to say whether the Chaworth Master learned to draw from the Queen Mary Master himself, or from examining and emulating the Queen Mary Master's work. Even if their relationship was not first-hand, that the Chaworth Master had access to the Queen Mary Master's designs itself reveals their creative proximity.

Allowing for the differences in scale, subject, and format, it is possible that the Chaworth Master's hand might be identified elsewhere in the corpus of manuscripts associated with the Queen Mary Master. Jeremy Griffiths thought that the Chaworth Master is close to one of the artists who collaborated with the Queen Mary Master in an Apocalypse manuscript now in the British Library (Royal MS 19 B XV) [fig. 7].[13] The illustrations in this Apocalypse are tinted drawings, and indeed the work of its second hand is comparable to that of the Chaworth Roll in technique, palette and style. However, the differences in the physical format of the book and the scale and finish of the miniatures between the Apocalypse and the roll make certain attribution difficult. While Lynda Dennison's research has focused primarily on 'fully-painted' miniatures by the Queen Mary Master and his associates, a comparable study of his tinted drawings and their influence would certainly further our understanding of this important and complex group of artists.

Fig. 3
King Edred (946-955) and King Edwy (955-959)

Fig. 4
Queen Mary Psalter: Pharaoh consulting with advisers. British Library, Royal MS 2 B VII, f. 17r

Fig. 5
Robert, Duke of Normandy (1027-1035)

Fig. 6
The Anglo-Saxon dynasty from Egbert (829-839) to Edward the Elder (899-924)

The Chaworth Roll is undoubtedly a valuable addition to the body of manuscripts that can be associated with the Queen Mary Master's style. It fits comfortably within the group of Queen Mary-style manuscripts, which are impressively varied in their content and patronage. The Chaworth Roll, dated to between 1321-7, was made during the height of the style's popularity, which flourished especially in the 1320s. The group includes Psalters, a Book of Hours, service books, religious miscellanies, an Apocalypse, a moral treatise, a legal compilation, and a French translation of Aristotle.[14] Even within this diverse corpus, the Chaworth Roll is unique both in its roll format and its content.

Made for destinations including Bangor, the diocese of Norwich, Canterbury, and Paris, manuscripts in the Queen Mary style were clearly much desired by patrons both close to London and far away.[15] Like these far-flung patrons who commissioned books in the Queen Mary Master style, the man who commissioned the Chaworth Roll – probably Sir Thomas Chaworth, based in Nottinghamshire – went out of his way to have his genealogical pedigree executed in this fashionable, elegant style.

Fig. 7
Queen Mary Apocalypse: miniature for Revelation 19. British Library, Royal MS 19 B XV, f. 38r

THE ROMAN ROADS AND THE WHEEL OF FORTUNE

The Chaworth Roll begins with three large circular drawings, which serve as a pictorial preface for the royal pedigree that follows [fig. 31]. The first two of these drawings are very rare, surviving in only one other of the thirteenth- and fourteenth-century genealogical rolls (see fig. 19, discussed below).[16]

The first of these roundels is a diagrammatic map of the Roman Roads of Britain [fig. 9]. No attempt has been made to represent the roads with geographical accuracy: four Roman roads divide the central circle of the diagram like wedges of pizza. Inscriptions identify the roads (reading from right to left) as Ikenild Street, Watling Street, Hermin Street, and Fosse Way. Eight small circles are arranged around the perimeter of the diagram, containing inscriptions naming the cardinal points and prevailing winds. The diagram is tinted with blue, green, red and orange, heightening its abstract, geometric quality.[17]

Fig. 8
The fall of a king: detail of the Wheel of Fortune

Following the Roman Roads is a drawing of the Wheel of Fortune. Lady Fortune stands behind her wheel, poised to give it a spin [frontispiece]. In one of the five verses that accompany the Wheel of Fortune, Fortune offers a warning to the king seated at the top of her wheel:

> Sire, great crowned king,
> You who have such high authority,
> Before whom the entire people bows,
> Whether rich or poor, great or small,
> Look to the left, downwards,
> How those who were before you
> Had their royal fate overthrown
> By the fortuitous snare;
> Therefore think you of death,
> For there is no predicting the moment of your downfall.

The consequences of Fortune's turning wheel are depicted around the perimeter of the wheel. The king's crown falls off, and he tumbles downward [fig. 8]. At the bottom of the wheel he is at his fortune's nadir, naked and supine as though crushed by the wheel's weight, before ascending once again. As he rises he is shown clothed and holding a coin, then combing his hair and holding a mirror, and finally, as a noble gentleman with a hooded gown and a hawk perching on

Fig. 9
Diagrammatic map of the Roman Roads of Britain

ticus.

iusep
tentuonalis

Eurus
austri.

oste

pacuditas cir

ad uulturnos

auster

Heruuestene.

Zephus
septentrionalis.

Zephir
austri.

cadens

aue
haut roy
couronne. Qui
ramt auetz de
dignete. Qui tut le
n uoue.
Richesse
peuple uous est enclinat.
deuauut.
Riches et puieres petit et gur.
i si frez bien.
Regardez a senestre enuers ual.
et court toure rien.
Cum il soit reuerse de ceo real.
plesse osties orgoil.
esme ames de sei a cou.
Ocus qui erent deuaunt uous.
nue que la roue gue.
cueurtir ne se aide une.

Fig. 10
Diagram of the Anglo-Saxon Heptarchy

Fig. 11
The Wheel of Fortune: wall painting in Rochester Cathedral, 13th century

Fig. 12
Holkham Bible Picture Book: Wheel of Fortune. British Library, Add. MS 47682, f. 1v

Fig. 13
Quest for the Saint Graal: Lady Fortune spins King Arthur on her wheel. British Library, Add. MS 10294, f. 89

his wrist. Four more verses about Fortune are arranged around the wheel, each accompanied by a man, probably a scholar judging from his cap.

The image of Fortune's Wheel can be traced to *Consolation of Philosophy*, written in the early sixth century while its author, Boethius was imprisoned on charges of treason. Boethius describes how Lady Philosophy appeared to him as he wept in his cell, bemoaning his terrible misfortunes. Reprimanding Boethius for his self-indulgent tears, Lady Philosophy tells him that the good fortune he had enjoyed never belonged to him, but to fickle Lady Fortune, and so he is mistaken to cry over the loss of something that was not his in the first place. 'Yes, rise up on my wheel if you like,' says Lady Fortune, 'but don't count it as an injury when by the same token you begin to fall.'[18] A powerful metaphor for the vicissitudes of fortune, the Wheel of Fortune was well known throughout the Middle Ages as both a literary and a visual image.

The Wheel of Fortune was especially popular in England during the later thirteenth and fourteenth centuries. Henry III commissioned a Wheel of Fortune to be painted in the Great Hall at Winchester Castle in 1236, and in 1247 he had another Wheel installed at Clarendon.[19] Henry III may also have been the patron of the Wheel of Fortune wall painting in Rochester Cathedral [fig. 11].[20] The image was adaptable and relevant in a variety of contexts. William de Braille's Wheel of Fortune, painted for a Psalter c. 1230-40, is interwoven with images of the ages of man from infancy to death, the rise and fall of a king, and the legend of Theophilus.[21] A rather different context for Fortune's wheel is the Westminster Bestiary, made c. 1270-80, in which it is the final image.[22] The Wheel of Fortune is one of the first images in the Holkham Bible Picture Book, a pictorial précis of the Old and New Testaments made in England in the 1320s [fig. 12]. Kingship and Fortune's Wheel are intertwined in the context of literary romance, as in the *Quest of the Saint Graal* made c. 1316, in which Lady Fortune spins King Arthur on her wheel [fig.13].[23]

The Chaworth Roll's verses set out Fortune's lesson: to 'Love God [...], hate sin above all things, love modesty, guard against pride [...] and to love your neighbour [...]', while the image itself serves as a reminder of Fortune's capricious nature. The full text of these poems is transcribed and translated on p. 37. The Wheel of Fortune is a profoundly appropriate preface for the royal genealogy that follows, preparing the viewer for a genealogical history peppered with unexpected reversals of fortune. By addressing a lordly audience directly in the verses ('You, who go climbing up this way, desiring riches and nobility'; 'Lords, think of death'), the Wheel also prompts the viewer to reflect not just on history but on his or her own position. Its message is stark and serious: no matter how rich or powerful, regardless of worldly wealth or power, 'all of us will die.'

THE ANGLO-SAXON HEPTARCHY

The third image in the Chaworth Roll's preface is a diagram of the seven kingdoms of the Saxon Heptarchy: Northumbria, Mercia, East Anglia, Essex, Kent, Sussex, and Wessex [fig. 10]. A short passage in the diagram's central roundel describes the size of Britain. Each of the seven kingdoms is identified by an inscription in a medallion arranged around the perimeter of the diagram, and a descriptive passage about each kingdom is inscribed in a circle inside. This map provides a snapshot of England in the time immediately before the reign of Egbert, the first king in the pedigree, whose reign marked the unification of hitherto disparate Saxon kingdoms.

henri le tierz

Edward con fiz · Margarete sa fille · Aimun con fiz · Beatris sa fille · Kateryne sa fille

Cestui Edward en sa iunesce qui primes fut fet chiualer
ala turneer en totes tres par la prouesche e puis ala en uele vint
chiualers en sa tere seyne e la de mesa my anni e de my e Elianore
sa rayne onek lui e la fut il souet en mesure mortele kaunde com
tre les sarazins e dunke lui vint nouele que son pere le Roy henri fut a
deu comaunde E pur ceo prist roi onek le soudan truu my anni e reuent
en engletere e fut croune Roy dengletere e puis auoyt truit a sere tote
sa uie contre gaileys e scoteys e puis contre le Roy de fraunce pur gascoyne
ki reuener ne pot en la tere seyne Cestui roy Edward regna xxxiiii
anns e prodoms e vynqst tous ses enemys e conquist gales e scotere e
gascoyne e en tuz ses fes fut droyturel e de gnt misericord e fut en tere
Weymoust

Cestui Thomas fut conte de lancastre e de
gloucestre e seneschal dengletere E il fut conte
de derby e par la contesse Alienore sa compaigne
il fut conte de Nicol e de Salebure

le Roy Edward

Elinore · Joan

Elia nore · Margarete · Johan · Henri · Joh · Elia nore · Margarete · Alfons · Edward · Thomas · Edmund

E est a sauer que des enfauns le bon Roy Edward par de sus purtrez Johe de Wyndesore sun primer
fiz morust tost Aymun de Wyndesore aui Elianore fut contesse de bar · margarete fut duchesse
de Breiloun Johane de ... fut Contesse de Gloucestre Elianore fut contesse de Heyplaunde
e fut espose al conte de herford e de ... Joane fut nonepne a Amberbure Alfouns de Bas
onc morust a Wyndesore Edward regna a pres sun pere Thomas fut conte de Suffolk e de
Norhtfolke e marschal dengletere Edmund de Wodestoke fut conte de kent

le Roy Edward

Fig. 14
Henry III (1216-1272) – Edward II (1327-1377) and his offspring

Fig. 15
Detail of Edward I's children

Unlike the unusual images of the Wheel of Fortune and the Roman Roads, the diagram of the Heptarchy is a standard feature of genealogical rolls of this period. Although the earliest-known comparable diagram of the Heptarchy is in British Library, Cotton MS Faustina B VII, dated 1216/17,[24] it was Matthew Paris who popularised it as a preface for genealogical chronicles. Paris devised an illustrated royal pedigree as a preface for his *Chronica Majora* and *Abbreviatio Chronicorum*, which begins with diagrams of the Anglo-Saxon Heptarchy. Two of Paris's Heptarchy diagrams survive (Cambridge, Corpus Christi College MS 26, f. iv verso, and Cotton MS Julius D VII, f. 5r).[25]

Following the tradition established in Roger of Wendover and Matthew Paris's *Chronica Majora*, many roll genealogies of the kings of England begin with a Heptarchy diagram. Sometimes, as in British Library, Add. MS 30079, it acts as a grand frontispiece of the genealogy, embellished with patterns and gold leaf. In other cases, such as British Library, Lansdowne Roll 3, it is a workmanlike diagram executed in pen and ink.[26]

THE CHAWORTH MASTER, HIS ASSISTANT, AND THE DATE OF THE ROLL

The first eight membranes of the Chaworth Roll are the core of the manuscript, containing the three large roundels and the royal pedigree from King Egbert to Edward II. Edward's death in 1327 marks the date before which the genealogy must have been completed. The depiction of his youngest daughter, Joan of the Tower, means that the roll must have been finished after her birth in 1321. Yet the dating of the Chaworth Roll is not as straightforward as it might at first appear.

Close inspection of the eighth membrane [fig. 14] reveals that it is not entirely the work of the Chaworth Master, who single-handedly illustrated the first seven membranes. A second artist – here nicknamed the Chaworth Assistant – contributed several portraits to the eighth membrane, and a second scribe copied the three textual passages on this membrane. On this membrane, which traces the royal pedigree from Henry III to Edward II and his children, the Chaworth Master drew Henry III and his five children; Edward I and four of his twelve children; and Edward II. Because the portrait of Edward II is certainly the work of the Chaworth Master, his work on the Chaworth Roll can be dated to Edward II's reign, 1307-27.

The Chaworth Assistant added to the genealogy roundels representing Thomas of Lancaster and Henry Plantagenet, the sons of Edmund 'Crouchback', younger brother of Edward I; representations of eight of the twelve offspring of Edward I; and Edward II's four children. Compared to the Chaworth Master, the Assistant's drawings are sketchy and angular. The contrast between the Assistant's portraits of Edward I's children and those of the Master is especially striking [figs. 15 and 23]. The Chaworth Master's figures are elegantly proportioned; their hands gesture gracefully; their gowns are washed with colour; their faces are finely drawn; and their hair suavely curled. The Assistant's figures are untinted; their hands claw-like; their hair tangled; and their faces indistinct. His style is close to that of the Master, but his execution gives the impression of haste, marked by a stuttering line and awkward proportions.

Since the Assistant, rather than the Master, executed the roundel containing Joan of the Tower, the youngest of Edward II's children, his contribution post-dates her birth in 1321. Indeed, it may be possible to narrow the date of Chaworth Assistant's work even further. The artist who drew eight of Edward I's children was also responsible for adding to the genealogy the roundels containing Thomas of Lancaster and Henry Plantagenet. This addition would have had particular significance for the Chaworth family, for Maud de Chaworth married Henry Plantagenet [fig. 23]. Accompanying these roundels is a text about Thomas of Lancaster, copied by a second scribe:

This Thomas was Earl of Lancaster and Leicester, and seneschal of England. He was also Earl of Derby, and through his wife the countess Alice, was Earl of Lincoln and Salisbury.[27]

Interestingly, this passage does not mention that Thomas was executed on 22 March 1322, and buried in the Priory of St John at Pontefract Abbey. Details of the place of burial are a fairly consistent feature of the other biographical sketches on the roll, but since this passage was the work of the second scribe it was probably composed later than the others, and so does not conform to its pattern. On the other hand, the fact that Thomas's death is not mentioned could mean that he was still alive, or very recently dead, when it was written. If so, the Chaworth Assistant's intervention in the genealogy would have taken place between Joan of the Tower's birth in July 1321 and Thomas's death in March the following year.

The Chaworth Master's final drawing was Edward II, so his work on the roll could arguably have been carried out any time during this twenty-year reign, between 1307-27, while the Assistant's contribution must have been made between 1321-7. From a stylistic point of view, the Chaworth Master's work seems more likely to have been executed towards the middle of Edward II's reign, sometime in the early 1320s, when the Queen Mary Master's style was in its heyday. How much time, then, might have elapsed between the work of the Chaworth Master and the Chaworth Assistant, or might they have worked side by side?

As discussed above, the niched arcade containing Edward I's children includes drawings by both Master and Assistant. The design of the arcade itself is reminiscent of contemporary architectural sculpture, and may even have been a deliberate evocation of Edmund Crouchback's elaborate tomb in Westminster Abbey (c. 1297), in which a row of weepers stand in an arcade of niches beneath Edmund's effigy [fig. 17].[28] Like the Crouchback tomb weepers, the Chaworth Roll's figures turn to face one another in pairs. In the Chaworth Roll, six of the niches have been left empty, perhaps representing some of the children who died in infancy.[29] The depictions of Edward's surviving children begin with Eleanor (b. 1264/9, d. 1297/8), who occupies the seventh niche. The last niche contains an image of a daughter, but unlike her siblings no inscription identifies her. This must be Edward I's youngest daughter Eleanor, born in 1306. The simplest explanation of the division of labour in the figures of Edward I's children is that the Master needed to draw the future Edward II in the arcade so that he would know where to position the green band leading to the portrait of Edward II as king, he drew the remaining three children, and left the remaining eight to his assistant.

Fig. 16
Edward III (1327-1377)

Collaboration between Master and Assistant may also explain the variation in the shade of green in the bands linking the roundels. Usually this green is a bright, clear verdigris, but the green wash in some of the bands is a muddier, darker shade. There are several examples of this second shade of green [fig. 18]. As mentioned above, in the pedigree, kings are represented twice: first in small roundels as their fathers' sons, and again in larger roundels as crowned monarchs, with bands linking the portraits. Olive green has been used for the bands connecting the small roundel of Edred (946-955) to his larger portrait as king, and the corresponding bands for Edwy (955-959) and Edgar (959-979). Many of these lines in the seventh and eighth membranes are also tinted with this olive green. Sometimes a band starts out in the more usual bright, clear verdigris and then carries in the darker shade (as in the line joining Edred's roundels), and in other cases the line peters out all together. This darker shade dominates the eighth membrane, with the Assistant's bands and roundels painted in this colour. These two-tone and incomplete lines suggest that the Chaworth Master may have left the tedious job of colouring in the green bands to his Assistant.

Fig. 17
Tomb of Edmund 'Crouchback', Westminster Abbey, c. 1297

Fig. 18
Edward the Elder (899-924) – Edgar (959-975) and his children

If Master and Assistant did indeed work together on the Chaworth Roll, then their work can be dated with confidence to the period 1321-1327, and speculatively to the nine month period between July 1321 and March 1322.

The fifteenth-century continuation of the genealogy to the Chaworth Roll included Edward III and his children, Richard II, and Henry IV (who succeeded to the throne in 1399) and his six children. Since Henry V is described 'Henri le prince', we can deduce that this section was completed before his accession to the throne in 1413. While the draughtsmanship of this continuation is very much of its period, in technique it closely imitates the Chaworth Master's work. The roundels are washed in with green, and the drawings tinted with the same transparent palette of green, blue and red [figs. 16, 26, 28].

TEXT AND CONTEXT:
THE CHAWORTH ROLL AND RELATED MANUSCRIPTS

The Chaworth Roll belongs to a large group of genealogical rolls that, in common with Chaworth, trace the pedigree of the kings of England from Egbert. Twenty of these manuscripts are discussed and catalogued in an indispensable thesis by William H. Monroe, and all of them are studied in a later thesis by Olivier de Laborderie.[30] Monroe and Laborderie showed that these genealogies grew out of a tradition established by Matthew Paris (b. circa 1200, d. 1259), the St Albans monk, artist and chronicler, who prefaced his *Chronica Majora* and *Abbreviatio Chronicorum* with brief genealogical chronicles and diagrams of the Anglo-Saxon Heptarchy.[31] From Egbert to Henry I, the historical text of these genealogical rolls is adapted from William of Malmesbury's *Gesta Regum Anglorum*, written before c. 1126.[32]

Within the group of roll genealogies, the Chaworth genealogy is remarkably similar to three other fourteenth-century rolls, two in Cambridge University Library (MSS Dd.3.58 and Oo.7.32) and one in the Bodleian Library (MS Fr. d. 1(R)).[33] Both the Bodleian roll and Dd.3.58 have suffered losses from their beginnings. The Bodleian roll is missing its first membrane, and begins with the prologue, while Dd.3.58 begins in *medias res* with King Harold II (1066). Furthermore, the transparent green paint used liberally in the genealogies – probably verdigris, a copper-based pigment – has had a caustic effect on the parchment of all of the rolls.[34] The Bodleian roll is the most severely affected, the verdigris having eaten away parts of the roll to such an extent that it is too fragile to consult.[35]

The lost sections of Dd.3.58 and the Bodleian roll notwithstanding, the four rolls are remarkably close in their texts, style, technique and design. Like the Chaworth Roll, Oo.7.32 begins with the prefatory series of three roundels, with Roman Roads, the Wheel of Fortune, and the Saxon Heptarchy [fig. 19]. Monroe argued convincingly that this first membrane of Oo.7.32 was added to the genealogy at the same time that additions were made on the penultimate membrane, and at the same time the last membrane was added, showing the children of Edward I, Edward II and his offspring. Thomas of Lancaster and Henry of Lancaster, the sons of Edmund 'Crouchback' were added to the genealogy, along with texts describing Thomas of Lancaster and listing the children of Edward I. These images and texts correspond to those in the Chaworth Roll. Because Edward II is shown as the reigning monarch and his youngest daughter, Joan (b. 1321) is depicted, these emendations to Oo.7.32 must have been made after Joan's birth and before Edward's death, between 1321-1327. The core of Oo.7.32, from Egbert - Edward I, must have been made during the reign of Edward I (1272-1307), possibly

Fig. 19
The Roman Roads, Wheel of Fortune and Anglo-Saxon Heptarchy. Cambridge University Library, MS Oo.7.32

Fig. 20
Swein 'Forkbeard', King of Denmark (985-1014) and ruler of England for a few weeks in 1013

making this manuscript the earliest of the four rolls. However, the core of Dd.3.58 was also produced during Edward I's reign, so Oo.7.32 could have been modelled on or copied from it.

Two other features set these four manuscripts apart from all other genealogical rolls listed by Monroe and Laborderie.[36] Swein 'Forkbeard', the Danish king who ruled England for a few weeks in 1013 and the father of Knut, appears in Oo.7.32, Chaworth, and the Bodleian roll, and was probably part of the section now missing from Dd.3.58 [fig. 20]. Since Swein is represented in Oo.7.32, one of the two earliest of the four manuscripts, this roll (or Dd.3.58) almost certainly served as the exemplar for at least one of the other three rolls. In contrast to the other genealogies, these four rolls all include the dukes of Normandy beginning with Richard II, Duke of Normandy (996-1026), and including Richard III, Duke of Normandy (1026-7), and William the Conqueror's father, Robert, Duke of Normandy (1027-1035).[37]

Monroe concluded that the artist of Oo.7.32 was also responsible for the Bodleian roll [fig. 21]. The work of a single artist, the Bodleian roll ends with the four children of Edward II, and so must have been made between 1321-7. The Bodleian roll cannot be examined because of its fragility, but a microfilm and colour slide (reproduced as fig. 21) confirm that its drawings and those of Oo.7.32 do indeed have some qualities in common, in Monroe's words 'high-waisted monarchs with uniformly cross expressions.'[38] Although the expressions on this artist's faces seem to have softened a little in the fifteen or so years that separate Oo.7.32 from the Bodleian roll, Monroe's attribution is convincing.

The Chaworth Roll, the Bodleian roll, and Oo.7.32 agree in continuing the genealogy to the children of Edward II: all three include Edward II's youngest child Joan, born in 1321. Additionally, all three include Edward I's children; the sons of Edmund 'Crouchback', Thomas and Henry, Earls of Lancaster; and related texts. Dd.3.58 is the odd roll out, ending with Edward I but not showing his offspring (these were added in the fifteenth century). It is possible that Dd.3.58 was copied from Oo.7.32 before the latter was amended, that is, before 1321. Alternatively, Dd.3.58 may have been completed first in the group, which is the hypothesis favoured by Laborderie.[39]

If the two Cambridge rolls belong to the period before c. 1321, possibly with Dd.3.58 made first and Oo.7.32 copied from it, then it stands to reason that the Chaworth and Bodleian rolls were made at the same time that the three roundels and other additions were made to Oo.7.32, between 1321-7.

The relationship between the Bodleian roll and the Chaworth Roll is especially close in their sections covering the reigns of Edward I and Edward II. Whereas Oo.7.32 depicts the offspring of Edward I in eleven roundels, the Bodleian and Chaworth rolls place twelve of Edward's children in a niched arcade (fig. 23). In both, the twelfth child (a daughter) is not named, but this is probably Eleanor, the daughter of Edward I and Margaret of France, born in 1306 (d. 1311). The figures in the niched arcades in the Chaworth and Bodleian rolls are arranged somewhat differently. In the Chaworth Roll, the first six niches are left empty. The Bodleian arcade also has empty niches, but these divide the figures in two, with the vacant spaces left between Alfonso (1273-83) and Edward (the future Edward II).

A sharp visual distinction is made in the Bodleian roll between the eight children on the left side and the four on the right, separated by five vacant niches. These children are also divided into two groups, although less emphatically, in the Chaworth Roll, with the four children on the right drawn by the Chaworth Master and washed in colour, and the other eight in black and white, drawn by the Chaworth Assistant. This distinction may be an attempt to mark out Edward I's potential heirs: the eight children on the left were all the children of

Fig. 21
Harold and the Norman Dukes. Bodleian Library, MS French d. 1 (R)

Fig. 22
Henry III – Edward I. Cambridge University Library, Dd.3.58

Fig. 23
Edward I and his children, and Thomas and Henry of Lancaster

Fig. 24
Descendents of William the Conqueror

Fig. 25
Descendents of William the Conqueror:
Henry I 'Beauclerk' and his wife Maud,
with their chidren William and Maud.
Cambridge University Library,
MS Oo.7.32

Eleanor of Castile (d. 1290). Of these eight, five died before Edward I's death in 1307, including three potential kings (John, d. 1271; Henry, d. 1274; and Alfonso, d. 1284). In the Chaworth and Bodleian genealogies, Edward I and Eleanor's youngest son Edward, the future Edward II, is grouped with Thomas of Brotherton, Edmund of Woodstock, and an unnamed sister (almost certainly Eleanor), who were the offspring of Edward I's second wife, Margaret of France.

The missing sections of the Bodleian roll and Dd.3.58 notwithstanding, these four rolls are almost identical in pictorial and textual content. Either Oo.7.32 or Dd.3.58 was probably the exemplar for the other three, directly or indirectly, explaining the similarities in content and layout within the group (e.g., compare figs. 24 and 25). What circumstances might explain the making of these manuscripts, and the amending of Oo.7.32? Could they have been made speculatively for the open market, as a batch, or might a single patron have wanted four nearly-identical genealogies? Examination of the Chaworth family tree reveals an intriguing possibility.

THE CHAWORTH FAMILY

Since 1885, Maud de Chaworth has been accepted as the patron of the Chaworth Roll. Jeremy Griffiths listed Maud de Chaworth and her granddaughter Blanche among the roll's owners.[40] Maud was the daughter and sole heir of Sir Patrick de Chaworth, Lord of Kidwelly (d. 1282/3) and Isabel de Beauchamp (d. 1306), and the first wife of Henry Plantagenet, later the 3rd Earl of Lancaster (b.1281, d. 1345). Maud died sometime before 3 December 1322, and was buried at Mottisfont Priory.[41] Maud and Henry Plantagenet married in c. 1296/7, and they had six daughters and one son between 1298 and 1317. As noted above, Henry Plantagenet was a son of Edmund 'Crouchback' Plantagenet (b. 1245, d. 1296): this made him a grandson of Henry III (b. 1206/7, d. 1272), and nephew of Edward I (b. 1239, d. 1307). Henry became the 3rd Earl of Lancaster after the death of his brother, Thomas of Lancaster, in 1322. Henry and Thomas Plantagenet were both added to the genealogy by the Chaworth Assistant, as mentioned above. Maud and Henry Plantagenet's son was Henry of Grosmont (b. circa 1300, d. 1361), a founding Knight of the Order of the Garter and Duke of Lancaster, whose daughter Blanche married John of Gaunt in 1359 [fig. 26]. Their son Henry usurped the throne from Richard II in 1399, thereby becoming Henry IV (b. 1366, acceded 1399, d. 1413). Ownership of such a genealogy would seem to be entirely appropriate for a woman whose marriage to Henry Plantagenet grafted the Chaworth family onto the royal family tree (see Family Trees, p. 35).

However attractive the supposed patronage of Maud de Chaworth may seem, there are good reasons to question this conclusion. Since the Chaworth family retained ownership of the roll until the late 1980s, it has been assumed that the roll somehow passed from Maud's descendents to the modern-day Chaworths. Griffiths suggested that the roll passed from Maud to her granddaughter Blanche (wife of John of Gaunt), and then by unspecified means to the modern Chaworths.[42] However, Maud de Chaworth was her father's sole heir and the last of the Kidwelly branch of the Chaworth line, and Maud and Henry's offspring were styled 'Plantagenet' rather than Chaworth.[43] For the roll to have passed from Maud's children to later generations of Chaworths, it would have had to jump from one branch of the family tree to another. But could some other Chaworth have commissioned the roll in the fourteenth century?

Another branch of the family descended from Maud's ancestor Patrick de Cadurcis (b. 1052).[44] These Chaworths were established in the mid-twelfth century as wealthy landowners in the East Midlands, and a series of advantageous marriages increased the family's lands exponentially over successive generations.[45] Sometime after 1374, Sir William Chaworth (b. 1352) married Alice Caltofte, the sole heiress of her father, Sir John Caltofte, and her uncle, Sir John Brett of Wiverton. Upon John Brett's death in c. 1385, Alice inherited the manor of Wiverton in Nottinghamshire, and henceforth the family was known as the Chaworths of Wiverton.[46]

The most likely member of this Wiverton branch of the Chaworth family to have commissioned the roll was Sir Thomas Chaworth, who was born in 1290, married in 1309, and died in 1347. Thomas's will may be the key to understanding the relationship between the Chaworth, Bodleian and Cambridge rolls. He made bequests to four children: John, Johanna, Alice, and Thomas. It may be that Thomas, Sr. commissioned one of the genealogies for each of his children. A fatherly desire to teach his brood the basics of English history could be seen as his motive for commissioning a genealogical roll for each of these children. Thomas, his heir, namesake, and executor, was born in 1310 and died in 1370/1, and so would have been between the ages of 10 and 17 when the Chaworth Roll was made. This fits with the hypothesis that the rolls may have been used to educate children.[47]

Fig. 26
John of Gaunt

Thomas Chaworth, Sr. may have acquired Dd.3.58, had Oo.7.32 copied from it and brought up-to-date, and commissioned the Chaworth Roll and the Bodleian roll so that each of his four children could have their own copy. This would explain the close textual and pictorial relationships between the four rolls, and also offers an explanation for the minor differences between them.

In 1330, Thomas (b. 1310) married Jane Luttrell, daughter of Geoffrey Luttrell, the patron of the famous Psalter, and at his father's death in 1347 he inherited the family estates.[48] If the Chaworth Roll passed from father to son, then its next owner would have been another Thomas (b. 1331, d. 1373), followed by William (b. 1352, d. 1398). Its subsequent owner would have been yet another Thomas Chaworth (b. 1380, d. 1459), a fabulously wealthy parliamentarian and remarkable bibliophile. Thomas's will and surviving manuscripts reveal that he assembled a remarkable library.[49] Thomas bequeathed to his eldest son William:

> a boke of Englissh ye which is called Policonicon, another boke of Notes of Fynes [....], the best Mes boke, another olde Messe boke with a boke of Placebo and Dirige liggying in his seid closed [i.e., closet] at the chapell, in the which ar titled of olde tyme the Obitts of the auncetors as welle of the faders of the said Sir Thomas as of his moder, the lesce Antiphoner of iiii., a Graile, a Manuell, a litel Portose, the which the saide Sir Thomas toke wt him always when he rode, a Sawter with Placebo and Dirige and a Hympner in the same [...][50]

Further devotional, historical and literary works were left to his children and others.[51] Thomas and his wife Isabella de Aylesbury commissioned the Wollaton Antiphonal, a massive, richly illuminated book made c. 1430.[52] The arms of Thomas, Isabella and their families are displayed throughout the book, and on f. 135 – the beginning of the Easter services – are Brett arms, representing the relations of Thomas from whom the Chaworths acquired Wiverton. Thomas's arms also appear in a copy of John Trevisa's translation of Bartholomaeus Anglicus' *De proprietatibus rerum*[53] and a copy of Lydgate's *Troy Book*.[54] The Bartolomaeus Anglicus and Lydgate manuscripts are not mentioned in Thomas's will, so the fact that the Chaworth Roll is not mentioned does not preclude his having owned it.

If Thomas did indeed own the Chaworth Roll, then its fifteenth-century addition can be attributed to his patronage with a degree of certainty. Thomas would have become the owner of the roll at the latest by the time of his father's death in 1398, and so it would have been in Thomas's hands when the genealogy was

Fig. 27
King Athelstan (925-939)

Athilitan.

extended between 1399-1413, and when another fifteenth-century genealogical roll (Cambridge University Library, MS Dd. 3.57) was copied from it. The Chaworth Roll might have attracted Thomas's interest on a number of levels, among them his familial ties to the royal family. As Simon Payling points out, the marriage of Maud de Chaworth and Henry of Lancaster meant that Thomas was a ninth cousin once removed of Henry IV, the last king depicted in the Chaworth Roll.[55] Thomas may also have been inspired to update the roll because of his dedication to the Lancastrian monarchy, demonstrated by his 1452 endowment of the Priory of Launde to pray for the souls of Henry V and his Queen, and for himself and his wife Isabella.[56] Also included in the genealogy's continuation is John of Gaunt, who married Maud Chaworth's granddaughter Blanche (b. 1341/5, d. 1369) in 1359.[57] As the son of Edward III and the father of Henry IV, John of Gaunt may have been of special interest to the Chaworths. In the continuation, he is pictured with the inscription 'S(ire) Jeh(an) de Gaunt' and from him descends 'Henri Lancast(re)', to become Henry IV.

Many of the continuations added to fourteenth-century genealogical rolls in the fifteenth century are executed in the contemporary style, resulting in jarring discontinuity in palette and style between the earlier and later sections (see, for example, fig. 22). This is conspicuously not the case in the Chaworth Roll: the continuation is executed in the same technique and colours as the earlier part of the roll. While the draughtsmanship of the roll's final membrane clearly belongs to the fifteenth century, it is clear that every effort was made to ensure that the addition would be aesthetically sympathetic to the original part of the roll. It seems reasonable to infer that this was the wish of its bibliophile patron. Sir Thomas, who would in 1399-1413 have been in the first phase of his book collecting, perhaps demonstrated precocious antiquarian tendencies in wanting to maintain the aesthetic of the early fourteenth-century in the addition to his heirloom genealogy.

It seems that the Chaworth Roll continued to be used more or less as it was originally intended long after the close of the Middle Ages. In his presentation to the Society of Antiquaries in 1885, Godwin mentioned that the Chaworth Roll was kept with a family pedigree. This pedigree is almost certainly the one 'drawn up by Glover for Sir George Chaworth in 1581', mentioned by Mrs L. Chaworth Musters in a pair of articles published in 1903 and 1904.[58] The Chaworth Roll and this Chaworth pedigree remained together at least until the late nineteenth century, and perhaps until the roll was sold by the Chaworth Musters family in 1988.

GENEALOGICAL ROLLS AS POPULAR HISTORY

The later Middle Ages witnessed the development of an increasingly literate English aristocracy with an appetite for books of devotion, literature and history, whose patronage fuelled a growing market for books produced by professional urban scribes and illuminators.[59] Whereas previously monasteries had exercised a virtual monopoly on the writing and preservation of historical chronicles, these lay readers commissioned translations and adaptations of chronicles into Latin and the vernacular languages of the English aristocracy, French and English.[60] This widespread interest in history is richly documented by surviving manuscripts. The most successful of these histories were the *Brut* chronicles, beginning with Wace's *Roman de Brut* written c. 1155, which recounted the legendary history of Britain from the fall of Troy, through the reign of King Arthur, and ending with the death of King Cadwalader.[61] The Anglo-Norman French *Brut* chronicle composed c. 1272 survives in at least 47 manuscripts, and there are more than 170 surviving copies in English.[62] Vernacular historical works did not exclusively focus on England's mythical past: Robert of Gloucester's *Metrical Chronicle*, written after c.1270, runs from the legendary foundation of Britain by Brutus to the year 1270. The *Short English Metrical Chronicle* also begins with Brutus, and ends with the accession of Edward

Fig. 28
Henry IV (1399-1413) and his children

II in 1307. According to Edward Kennedy, the *Short English Metrical Chronicle* was 'probably intended to offer a rapid survey of English history and to teach the main facts to the uneducated through recitation or memorization.'[63]

The Chaworth Roll and its contemporaries satisfy precisely this desire for a straightforward, memorable survey of English history. Thomas Wright, who edited and translated a version of the texts in the Chaworth Roll in 1872, suggested these genealogies were probably commissioned by wealthy laymen as 'popular historical manuals […] for the instruction of [their] children.'[64] More recently, Michael Clanchy suggested that 'They were perhaps intended for laymen of restricted literacy.'[65]

Written in Anglo-Norman French, the Chaworth Roll can be seen as a medieval equivalent of a popular modern television series on the monarchy, in content if not in mass appeal. Pithy and memorable, its texts grab the reader's attention with tales of military prowess, blunt condemnations of weak leadership and moral turpitude, praise for godliness, and harrowing accounts of treachery and misfortune. The basic facts of each king's life are set out in mini-biographies that describe his family ties, the duration of his reign, and place of burial, as well as a short sketch of the character of the reign. These passages are an animated overview of the kings of England, seasoned with traitors, piety, battles, saints, sinners and incidents of divine intervention.

The descriptive passages that accompany the portrait roundels are richly anecdotal, summarizing each reign's decisive moments, significant deeds, and punchy assessments of each monarch's moral character and political achievements. Unambiguous judgements, good and bad, are presented forthrightly. King Edwin (955-959) was 'bad and lustful, and behaved badly towards God and all people.' After his death, the text explains, Edwin avoided eternal damnation only through the prayers of St Dunstan who, hearing from a demon that Edwin's soul was being carried to hell, prayed to Jesus. William Rufus's assassination by Walter Tyrel seems justified in light of the text's assessment that Rufus was bad to strangers, kin, and even to himself, and that his funeral was a joyous occasion at which not a single tear was shed. King John's reign is lamented: 'Alas! what grief! Among all Christian kings, he was previously the most free, and from his own degree of free made himself a serf, and made the glorious realm of England a tributary.' In some cases, however, where one might expect editorial comment, events are presented with surprising neutrality. For example, the passage on Henry II mentions that during his reign 'St Thomas was martyred', but is silent on why or by whom, perhaps assuming that this episode was sufficiently notorious.

Fig. 29
Elthelred (865/6-871)

Supernatural forces are also at work in the Chaworth Roll's history of England. St Dunstan, the tenth-century English abbot, Archbishop of Canterbury and statesman (b. circa 924, d. circa 988), is a key figure in the roll's early passages. In a story betraying a rather loose grip on historical chronology, King Egbert (802-839) hears an angel announcing Dunstan's birth (which was probably c. 909, some sixty years after Egbert's death): 'Peace, as long as this man reigns and Dunstan lives.' St Dunstan hears an angel's voice when King Edred dies (946-955), and, as mentioned above, when evil Edwy dies in 959, Dunstan's prayers save his soul from the torments of hell [fig. 3]. At the baptism of the future King Ethelred (979-1016), Dunstan prophecies that 'the course of life to this man shall be cruel in commencement, miserable in the middle, and unhappy in the end' after the infant urinates in the font.

The Chaworth Roll's ideal king is virtuous, pious and devout. We are told of Ethelwulf's generosity to the church and to the poor, and of his pilgrimage to Rome. Edgar is praised as the most holy king, father of Edward the Martyr and St Edith, and founder of many monasteries. Piety is shown to confer military advantages, as when Ethelred saved England from the Danes during the battle

ſelle eſteıt den ſaue ƥroıte d ẜoıllıe
o en lın tꝛns ſen nettoꝛeẜut nul roꝛ
on q̄ tꝛgua:

echeꝛ
ꝑeıe
nt
e

DSARD.

Fig. 30

Edgar (959-975)

of Assingdon. On the morning of the second day of battle, Ethelred refused to join his men on the battlefield until after Mass. Despite being summoned many times, 'he would not go out of church until Mass was said for any living man'. After Mass, he signed himself with the cross, took up his lance, and killed two of the Danish kings and five of their earls, thus securing the English victory. When Hugh of France wished to marry Athelstan's fair sister Eadhild, he sent Athelstan precious objects and relics, including nails and part of the cross, the crown of thorns, and the banner of St Maurice. Delighted with these gifts, Athelstan sent Eadhild to France. The sanctity of some kings is asserted in some passages, while in others it is implicit. Forty years after the death of King Edgar (959-975), his body is discovered miraculously incorrupt, 'blood running from him all fresh and new, and for his miracles he was held for a saint.' By contrast, the text is curiously silent on the sanctity of Edward the Confessor: the passage concentrates on his legal reforms, and on his desire for William the Conqueror to succeed him, but nothing about religious foundations or devotion.

Although the Chaworth Roll contains no explicit statement of its intentions, its didactic purpose is implicit. The prologue contains the remark that 'there is no nation in the world that serves God and the blessed Church in such a courtly manner or with such devotion.' The genealogy might be viewed as a document that tries to demonstrate that this is so, yet its ambition is not merely nationalistic. By detailing, and condemning, the deeds of impious, weak or foolish kings, the Chaworth Roll reveals the imperfections in England's past while at the same time promoting the virtue of devotion, courage, duty, and piety. This preoccupation with morality, signaled at the opening of the genealogy by Lady Fortune and her cautionary verses, is a function of the roll's double purpose to narrate history and also to remind its audience of the consequences of pride, lust, treachery and wickedness.

MAKING HISTORY: THE PURPOSE OF THE CHAWORTH ROLL

The Chaworth Roll gallops through English history, presenting almost six hundred years in 6.5 metres of parchment. Despite this breakneck pace, at times it might seem to us formulaic or even derivative. Yet it is worth recalling that it would not have seemed so for its first owners, most likely Thomas Chaworth and his young family. As the roll was unfurled before them, the spectacle of English history, with its kings and queens, saints and sinners, heroes and villains, was laid out. Perhaps these very readers, their appetites whetted by the images and stories of the Chaworth Roll, were among the patrons of the vernacular historical chronicles that grew in popularity over the course of the fourteenth century. Having been introduced to the pleasures and interest of history through genealogical chronicles, they may have turned to works such as the *Short English Metrical Chronicle*, one of the many works which might have served as 'further reading' after the Chaworth Roll's potted history.[66]

The Chaworth Roll's significance as a work of history lies not in the novelty of its content or the depth of its analysis, but rather in the audience for whom it was made. It belongs to a new genre of historical writing that made history accessible to lay people, hungry for knowledge but unable to read Latin historical chronicles. While the roll adds nothing to what we know about English royal history in the Middle Ages, it is an important witness to the historical understanding that wealthy lay people could attain in the early fourteenth century.

While the Chaworth Roll's value as a historical document is of undoubted significance, arguably its greatest importance is as a work of art. Dating to the period between 1321-7, the roll was made at the height of the Queen Mary Master style's popularity. And, unlike many of the Queen Mary Master's works which, like the Psalter itself, were of uncertain provenance, we can be reasonably sure that it was commissioned by the Chaworth family of Nottinghamshire. The precision with which the roll can be dated and attributed to a specific patron makes it a valuable addition to the corpus of works connected to the Queen Mary style, many of which can neither be precisely dated nor connected to original or early owners. Among its many remarkable qualities, the fact that the Chaworth Roll remained in the hands of the family for whom it was made in the fourteenth century until 1988 has special resonance. Perhaps it is not too far fetched to suggest that it represents an experience common to school children, medieval and modern, who grumblingly sit down to study the kings and queens of England, only to discover that the story of England's throne is an absorbing tale of brave deeds, skullduggery, bloody battles and noble intentions.

NOTES

1 5 February 1885, *Proceedings of the Society of Antiquaries*, 2nd series, 10 (1883-1885), 197-99.

2 *Sam Fogg Rare Books: Medieval Manuscripts*, Catalogue 12 (London, 1989), no.10, 38-9; Jeremy Griffiths, 'Manuscripts in the Schøyen Collection Copied or Owned in the British Isles before 1700,' *English Manuscript Studies 1100-1700*, ed. Peter Beal and Jeremy Griffiths, 5 (London, 1995), 36-42, MS 250, 42; Olivier de Laborderie, 'Les généalogies des rois d'Angleterre sur rouleaux manuscrits (milieu XIIIe siècle): Conception, diffusion et fonctions' in *La généalogie entre science et passion*, ed. Tiphaine Barthelemy and Marie-Claude Pingaud (Paris: Editions du CTHS, 1997), 185-193.

3 This hand can be described more precisely as *Textualis semi-quadrata*: for a discussion of this terminology, see Michelle P. Brown, *A Guide to Western Historical Scripts from Antiquity to 1600* (London and Toronto, 1990), 86, 30.

4 British Library, Royal MS 2 B VII. The key studies of the *Queen Mary Psalter* are George Warner, *Queen Mary's Psalter* (London, 1912); Lucy Sandler, *Gothic Manuscripts 1285-1385, A Survey of Manuscripts Illuminated in the British Isles*, (London, 1986), i, 30-31; ii, nos. 56, 65-66; and Anne Rudloff Stanton, *The Queen Mary Psalter: A Study of Affect and Audience*, Transactions of the American Philosophical Society, vol. 91, pt. 6, (Philadelphia, 2001).

5 A date between c. 1318 and c. 1320 has recently been proposed by Anne Rudloff Stanton, *The Queen Mary Psalter*, 239 and passim.

6 The Queen Mary Master also illuminated the Psalter of Richard of Canterbury, New York, Pierpont Morgan Library MS G. 53 (Sandler, no. 57); a devotional miscellany, Paris, Bibliothèque Nationale MS fr. 13342 (Sandler, no. 58); and a fragmentary miscellany, Oxford, Bodleian Library MS Douce 79 (Sandler, no. 59).

7 Sandler, *Gothic Manuscripts*, i, 30. For Sandler's discussion the Queen Mary Master style see *Gothic Manuscripts*, i, 30-31, and ii, cat. nos. 56-77. For the Queen Mary group, see also J. J. G. Alexander, 'Early Fourteenth-Century Illumination; Recent Acquisitions,' *Bodleian Library Record* IX (1974), 72-80.

8 Sandler, *Gothic Manuscripts*, i, 30.

9 Jonathan J. G. Alexander, *Medieval Illuminators and their Methods of Work* (New Haven and London), 127.

10 Lynda Dennison, 'An Illuminator of the Queen Mary Psalter Group: The Ancient 6 Master,' *Antiquaries Journal* 66 (1986), 287-314.

11 Lynda Dennison, '"Liber Horn", "Liber Custumarum" and Other Manuscripts of the Queen Mary Psalter Workshops,' in *Medieval Art, Architecture and Archaeology in London*, ed. Lindy Grant (British Archaeological Association Conference Transactions for the year 1984) (London, 1990), 118-134.

12 Dennison, '"Liber Horn"', 129.

13 Jeremy Griffiths, unpublished report on the Chaworth Roll, 19.03.1988. See also Griffiths, '*Manuscripts in the Schøyen Collection*', 42.

14 See Sandler, *Gothic Manuscripts*, ii, nos. 56-77.

15 See Sandler, *Gothic Manuscripts*, i, 31.

16 The Roman Roads diagram is also present in Cambridge University Library, MS Oo.7.32. It was probably in another manuscript derived from MS Oo.7.32, Oxford Bodleian Library, MS French D.1 (R), and may also have been in Cambridge University Library, MS Dd.3.58.; unfortunately, both those manuscripts have lost their initial section. Additionally, a diagram of the Roman Roads is in a roll that was probably copied from the Chaworth Roll dating to the reign of Henry IV: Cambridge University Library, MS Dd.3.57. For this later roll, see Olivier de Laborderie, '*Ligne de reis*'. *Culture historique, représentation du pouvoir royal et construction de la mémoire nationale en Angleterre à travers les généalogies royales en rouleau du milieu du XIIIᵉ siècle au début du XVᵉ siècle*, PhD thesis, (Paris, E.H.E.S.S., 2002), 255 and 1365.

17 Laborderie, '*Ligne de reis*', 851, discusses the political implications of this diagram, which he sees as a representation of Great Britain's political unity under the king of England.

18 Boethius, *The Consolation of Philosophy*, trans. Victor Watts, revised edition (London, 1999), 25.

19 Paul Binski, *The Painted Chamber at Westminster* (London, 1986), 44.

20 E. W. Tristram, *English Medieval Wall Painting: The Thirteenth Century* (Oxford, 1950), 286-9. For fourteenth-century examples, see E. W. Tristram, *English Wall Painting of the Fourteenth Century*, Ed. Eileen Tristram (London, 1955), 27-28.

21 Cambridge, Fitzwilliam Museum, MS 330: see Nigel Morgan, *Early Gothic Manuscripts (I) 1250-1285* (London, 1988), i, 72a.

22 London, Westminster Abbey Library MS 22, f. 54v: see Nigel Morgan, *Early Gothic Manuscripts (II) 1250-1285* (London, 1988) no. 172, 173-4.

23 British Library, Add. MS 10294, f. 89.

24 W. H. Monroe, '13th and early 14th-century Illustrated Genealogical Manuscripts in Roll and Codex: Peter of Poitiers' *Compendium, Universal Histories and Chronicles of the Kings of England*, PhD thesis, (Courtauld Institute of Art, University of London, 1990), vol 2. 267.

25 Suzanne Lewis, *The Art of Matthew Paris in the Chronica Majora* (Aldershot, 1987), 168-71.

26 Of the 19 examples of the genealogical rolls starting with Egbert listed by Laborderie, 15 definitely include the Heptarchy, and there is evidence that three others once did so as well: Laborderie, '*Ligne de Reis*', 1445. See also Monroe, '13th and early 14th-century Illustrated Genealogical Manuscripts', catalogue D.

27 'Cestui Thomas fut counte de Lancastre e de Leycestre e seneschal d'Engletere. E si fut counte de Derby e par la contesse Aleyse, sa compaigne, il fut counte de Nicol e de Saleburi.' Transcribed by Olivier de Laborderie, translated by Marigold Anne Norbye.

28 Paul Binski, *Westminster Abbey and the Plantagenets: Kingship and the Representation of Power, 1200-1400* (New Haven, 1995), 113-20 and passim.

29 These children include Joan (d. 1260), Katherine (d. 1264), Joan (d. 1265), Berengaria (1276-1279), Isabella (d. 1279), Alice (b. 1279, d. 1291), Beatrice (b. 1286, d. soon thereafter), and Blanche (d. 1290): see T. Anna Leese, *Blood Royal: Issue of the Kings and Queens of Medieval England 1066-1399* (Bowie, Maryland, 1996), *Blood Royal*, 94-122.

30 Monroe, '13th and early 14th-century Illustrated Genealogical Manuscripts' (Monroe does not include the Chaworth Roll); Laborderie, '*Ligne de reis*'.

31 See Monroe, '13th and early 14th-century Illustrated Genealogical Manuscripts', 260-5, Laborderie, '*Ligne de reis*', 423-483, and Lewis, *The Art of Matthew Paris*, 135-242.

32 Monroe, '13th and early 14th-century Illustrated Genealogical Manuscripts', 275. For the *Gesta Regum Anglorum*, see William of Malmesbury, *Gesta Regvm Anglorvm: The History of the English Kings*, vol. 1, ed. and trans. by R. A. B. Mynors, R. M. Thompson and M. Winterbottom (Oxford, 1998) and vol. 2, *General Introduction and Commentary*, R. M. Thompson and M. Winterbottom (Oxford, 1999).

33 For Cambridge University Library Dd.3.58, see *Catalogue of Manuscripts preserved in the Library of the University of Cambridge*, i, no. 145, 152; for Cambridge University Library Oo.7.32, see *Catalogue of Manuscripts preserved in the Library of the University of Cambridge*, iv, no. 3219, 543. For Oxford, Bodleian Library, MS Fr. d. 1 (R), see Falconer Madan and H. H. E. Craster, *A Summary Catalogue of Western Manuscripts in the Bodleian Library at Oxford*, Vol. vi (accessions, 1890-1915) (Oxford, 1924), no. 32859; and O. Pächt and J. J. G. Alexander, eds. *Illuminated Manuscripts in the Bodleian Library, Oxford, Vol. 3, British, Irish and Icelandic Schools* (Oxford, 1973), 53-54, 583. There is a fifth roll, dating from the reign of Henry IV, Cambridge University Library, MS Dd.3.57, which is a direct copy of the Chaworth Roll, with identical textual variants and the same genealogical diagram, according to Laborderie, '*Ligne de reis*', 255.

34 See Hermann Kühn, 'Verdigris and Copper Resinate' in *Artists' Pigments: A Handbook of Their History and Characteristics*, vol. 2, ed. A. Roy (Oxford, 1993), 131-147; see esp. 137 for its destructive properties.

35 My observations about Bodleian, MS Fr. d. 1 (R) are based on a black and white microfilm and a 35 mm slide. Unfortunately I am unable to illustrate this section of the roll as its fragile condition prevents new photography.

36 Monroe, '13th and early 14th-century Illustrated Genealogical Manuscripts', 278. Laborderie, '*Ligne de reis*', 281 and 775.

37 Monroe, '13th and early 14th-century Illustrated Genealogical Manuscripts,' 325. Laborderie, '*Ligne de reis*', 281.

38 Monroe, '13th and early 14th-century Illustrated Genealogical Manuscripts', 325. Laborderie, '*Ligne de reis*', 255, endorses Monroe's opinion.

39 Laborderie, '*Ligne de reis*, 255.'

40 Griffiths, 'Manuscripts in the Schøyen Collection', 42.

41 G. E. Cokayne, *The Complete Peerage*, ed. H. A. Doubleday and Lord Howard de Walden (London, 1929), vii, 400. See also Leese, *Blood Royal*, 82, 102, 130, 363 and passim.

42 Griffiths, 'Manuscripts in the Schøyen Collection', 42.

43 See Bernard Burke, *A Genealogical History of the Dormant, Abeyant, Forfeited, and Extinct Peerages of the British Empire* (London, 1883), 111-2.

44 For the permutations of the Chaworth name see Mrs L. Chaworth Musters, 'Some Account of the Chaworth Family called in Latin Cadurcis, in French Chaources, in English Chaworth', *Transactions of the Thoroton Society 7* (1903), 119-138, and continued, 8 (1904), 67-78.

45 See Simon Payling, *Political Society in Lancastrian England: the Greater Gentry of Nottinghamshire* (Oxford, 1991), 22-27, and Appendix 4.2, 'Chaworth of Wiverton', 232.

46 Ibid.

47 Thomas Chaworth's Latin will, dated 1347, is published in *Testamenta Eboracensia or Wills Registered at York*, i (London, 1834), 47-8.

48 London, British Library, Add. MS 42130.

49 A. S. G. Edwards, 'The Contexts of Notre Dame 67,' in *The Text in the Community: Essays on Medieval Works, Manuscripts, Authors and Readers*, ed. J. Mann and M. Nolan (Notre Dame UP, 2005), forthcoming.

50 For this will see *Testamenta Eboracensia*, ii, 227. For a discussion of this will, see Edwards, 'The Contexts of Notre Dame 67'. I am grateful to Prof. Edwards for sharing this paper with me before publication.

51 *Testamenta Eboracensia*, ii (London, 1855), 220-229.

52 University of Nottingham, MS 250. See Richard Marks and Paul Williamson, *Gothic: Art for England 1400-1547* (Victoria and Albert Museum exhibition catalogue: London, 2003), 421, no. 312; Kathleen Scott, *Later Gothic Manuscripts 1390-1490* (A Survey of Manuscripts Illuminated in the British Isles: London, 1996), 204-6, no. 69; and N. R. Ker, *Medieval Manuscripts in British Libraries, IV: Paisley-York* (Oxford, 1992), 667-68.

53 New York, Columbia University Library, MS Plimpton 263, f. 9r. See see M. C. Seymour et al., eds., *On the Properties of Things: John Trevisa's Translation of Bartholomaeus Anglicus De Proprietatibus Rerum*, vol. 3 (Oxford, 1988), 19-22.

54 London, British Library, MS Cotton Augustus A. iv.

55 Payling, *Political Society*, 26 n. 34.

56 J. C. Wedgwood, *History of Parliament: Biographies of the Members of the Commons House 1439-1509*, (London, 1936), i, 176.

57 See Leese, *Blood Royal*, 'The Marriages of John of Gaunt', 201-219.

58 L. Chaworth Musters, 'Some Account of the Chaworth Family called in Latin Cadurcis,' 124.

59 For the development of lay literacy in England see Michael T. Clanchy, *From Memory to Written Record. England 1066-1307*, 2nd ed. (Oxford, 1993) and Malcolm B. Parkes, 'The Literacy of the Laity' in *Literature and Civilisation: The Medieval World*, ed. D. Diachus and A.K. Thorlby, 555-576 (London, 1973), repr. in *Scribes, Scripts and Readers: Studies in the Communication, Presentation and Dissemination of Medieval Texts*, ed. M.B. Parkes and M. Beckwith (London, 1991), 275-297. For an overview of the effect on the production of luxury books, see Christopher de Hamel, *A History of Illuminated Manuscripts* (London, 1994), 'Books for Aristocrats', 142-167.

60 For chronicles and genealogies in Middle English, see Edward Donald Kennedy, 'Chronicles and Other Historical Writing', in *A Manual of the Writings in Middle English 1050-1500*, gen. ed. Albert E. Hartung, vol. 8 (New Haven, 1989).

61 Kennedy, *Chronicles and Other Writing*, 2611-2617.

62 Kennedy, *Chronicles and Other Writing*, 2611-2617

63 Kennedy, *Chronicles and Other Writing*, 2622.

64 Thomas Wright, *Feudal Manuals of English History* (London, 1872), xi.

65 Michael Clanchy, *From Memory to Written Record: England 1066-1307*, 2nd edition (Oxford, 1995), 142.

66 E. Zettl, ed., *An Anonymous Short English Metrical Chronicle*, Early English Text Society, Original Series, 196 (London, 1935).

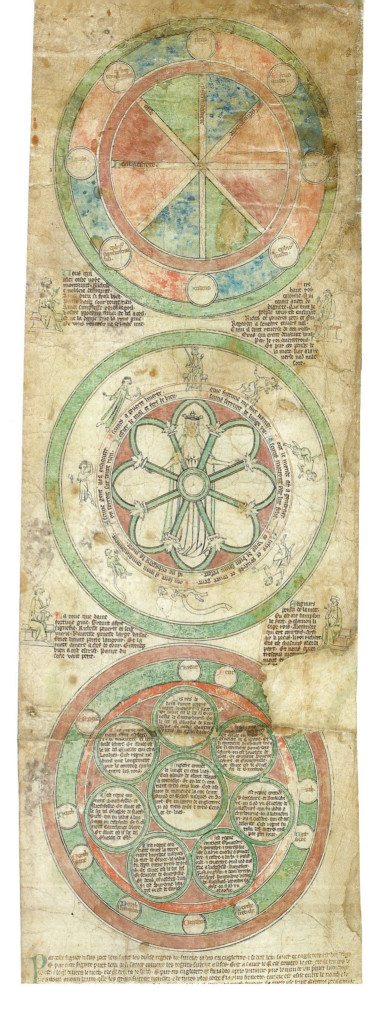

Fig. 31

The Roman Roads, Wheel of Fortune and Anglo-Saxon Heptarchy

FAMILY TREES OF THE CHAWORTHS AND PLANTAGENETS

PLANTAGANETS & DUKES OF LANCASTER

CHAWORTHS

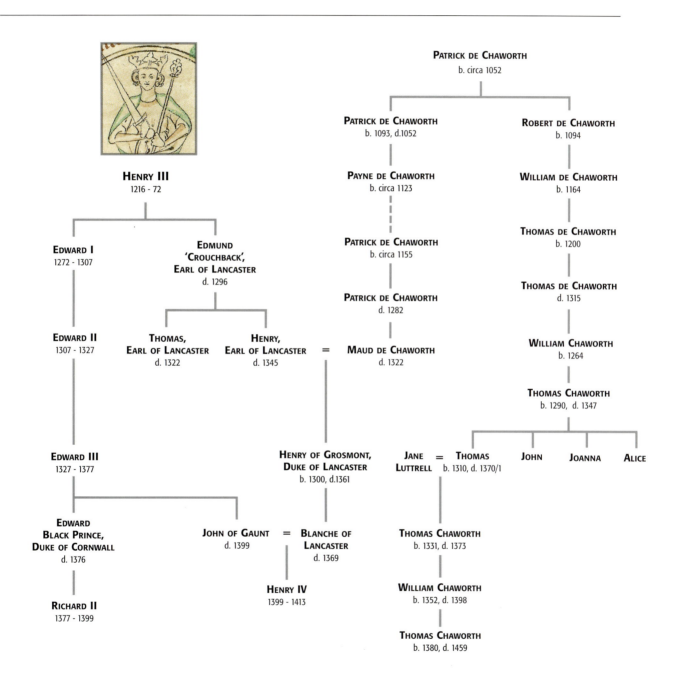

HENRY III
1216 - 72

EDWARD I
1272 - 1307

EDMUND 'CROUCHBACK', EARL OF LANCASTER
d. 1296

EDWARD II
1307 - 1327

THOMAS, EARL OF LANCASTER
d. 1322

HENRY, EARL OF LANCASTER
d. 1345

= **MAUD DE CHAWORTH**
d. 1322

EDWARD III
1327 - 1377

HENRY OF GROSMONT, DUKE OF LANCASTER
b. 1300, d.1361

EDWARD BLACK PRINCE, DUKE OF CORNWALL
d. 1376

JOHN OF GAUNT
d. 1399

= **BLANCHE OF LANCASTER**
d. 1369

RICHARD II
1377 - 1399

HENRY IV
1399 - 1413

PATRICK DE CHAWORTH
b. circa 1052

PATRICK DE CHAWORTH
b. 1093, d.1052

ROBERT DE CHAWORTH
b. 1094

PAYNE DE CHAWORTH
b. circa 1123

WILLIAM DE CHAWORTH
b. 1164

PATRICK DE CHAWORTH
b. circa 1155

THOMAS DE CHAWORTH
b. 1200

PATRICK DE CHAWORTH
d. 1282

THOMAS DE CHAWORTH
d. 1315

WILLIAM CHAWORTH
b. 1264

THOMAS CHAWORTH
b. 1290, d. 1347

JANE LUTTRELL = **THOMAS**
b. 1310, d. 1370/1

JOHN

JOANNA

ALICE

THOMAS CHAWORTH
b. 1331, d. 1373

WILLIAM CHAWORTH
b. 1352, d. 1398

THOMAS CHAWORTH
b. 1380, d. 1459

The first three dukes of Normandy:
Rollo (b. 857, d. 927),
William (b. 876, d. 942)
and Richard I 'The Fearless' (b. 933, d. 996)

Richard le secund.

Richard son fiz. · Robert son fiz. · Willem le moine. · Alice la cuntesse. · Une cuntesse de [...] · Mauger ercevesqe.

Richard le vieil duk de Normundie · Robert duk de Normundie

Willem bastard.

Cesti Robert duk de Normundie apres Richard sun frere il fu prodome e mult ama gent de religion · e volentiers fist bien a poures · il fu large donour. ço mustra il souent fez · entre les autres choses q il dona souent · auint q il fu en mustier le iour de Nowel e q̃nt uint al offrendre · le duc e les cheualers alerent offrir · auint q le duc les garda un poure cheualer en mustier q̃ ne auoit point de offrendre · il apela un chambleyn a les cõmanda q il li portast cent mars a offrir · e il si fist · e le cheualer prist les cent mars si les ala offrir e çel cune maille · le duc se merueilla · e nequent e mult pria le cheualer · pur ço q il li furet donez en noun de offrendre · e repela le chambleyn · e li fist de rechef portt · C · mars pur aquiter ses gages · i cesti Robert nauoit nule fẽme espose mes il amala fille un vilois de la uile · si engendra de lui Willem le bastard q puis fu rei dengletere · il fit nõrir lenfant · e li tint ausi ch̃ cũ il le eust eu de sa espuse · puis li prist talent de aler en la tere seinte · e fist sun eir Willem sun fiz.

Cesti richard le tierz fu duc de Normundie apres sun pere · il cõmenca rederment · e produme ente · si cũ eust dure · mes il ne uesqui q̃ deus anz e mo rut e gist a feschãp.

Cesti Willem bastard conquerour dengletere q̃ con quist le reaume par bataille de Harald q̃ le g̃ tint a tort · i cesti Willeme fu duc de Normundie trente anz rei dengletere · xx · ii · anz · il fu coroune euesche au de g̃ce · M · c · lxvii · le iour de Nowel del ercueueske de Ebͬ Aldͬ e morut en le an de g̃ce cinq̃nte neuueme an.

TRANSCRIPTION & TRANSLATION OF SELECT PASSAGES

TRANSCRIBED BY
DR OLIVIER DE LABORDERIE

TRANSLATED BY
DR MARIGOLD ANNE NORBYE

ADDITIONAL EXPLANATIONS AND MODERN
SPELLINGS OF NAMES ARE IN SQUARE BRACKETS.

Knut King of England (1016-1035),
Hardeknut King of England (1035-1037
and 1040-1042)

La roue que Dame Fortune guie
Graunt afere signefie :
Richesse, poverté e seignurie,
Hautesse, pruesse, large baillie,
Force, beauté, pecché, langour,
Et la mort amere a chef de tour.
Entendez bien a cest escrist :
Pompe du secle vaut petit.

Vous qui alez ceste voye mountaunt,
Richesse e nobleie desiraunt,
Amez Dieu, si freez bien,
Pecché haiez sur toute rien,
Amez simplesse, ostiez orgoil,
Vostre proesme amez de bel acoil,
Que la dame que la roue guie
De vous reversir ne se haste mie.

Sire haut roy corouné,
Qui taunt avetz de digneté,
Qui tuit le poeple vous est enclinant,
Riches et poveres, petiz e granz,
Regardez a senestre envers val
Cum il sont reversé de ceo real
Ceus qui erent devaunt vous
Par le roy aventerous
Et pur ceo pensez de la mort
Kar a la reverse n'ad nule sort.

Seignurs, pensez de la mort
Ou est ore Sampson le fort,
Salamon li sage rois,
Alexandre qui ert courtois,
Arthur li preus, li roy Richart ;
Ore est chascuns alez sa part.
Et nous aprés trestouz morroms,
(Coment e quant, ne siet nuls homs.)

Verses written in wheel :

Dame Fortune me face nomer.
Tout le monde ay a governer,
Riches et poveres et toute gent,
Touz sont a mon comaundement.

Ascune gent voil enhaucer,
Ascunes a poverté liverer.
Ascuns serrunt de lunge vie,
Ascuns morront par lur folie.

Jeo vous di bien saunz resort :
Nul ne eschapera la mort.
Bon serroit sur toute rien
Laissier le mal et fere le bien.

The wheel which Lady Fortune controls
Indicates important matters:
Riches, poverty and lordship,
High rank, prowess, a large jurisdiction,
Strength, beauty, sin, disease,
And bitter death in the end.
Understand well what is written here:
The pomp of this world is worth little.

You who go climbing up this way.
Desiring riches and nobility,
Love God, thus will you spend well,
Hate sin above all things,
Love modesty, guard against pride,
Love your neighbour with a warm welcome,
So that the Lady who drives the wheel
Does not hasten to throw you down.

Sire, great crowned king,
You who have such high authority,
Before whom the entire people bows,
Whether rich or poor, great or small,
Look to the left, downwards,
How those who were before you
Had their royal fate overthrown
By the fortuitous snare;
Therefore think you of death,
For there is no predicting the moment of your downfall.

Lords, think of death,
Where Samson the strong is now,
Solomon the wise king,
Alexander who was courtly,
Arthur the worthy, king Richard [the Lionheart];
Now each has gone his way,
And after them, all of us will die,
How and when, no one knows.

Let me be called Lady Fortune,
I govern the whole world:
Rich and poor and all people
Are all under my command.

Some people I wish to raise up,
Others I wish to reduce to poverty;
Some will have a long life,
Others will die of their own folly.

I tell you this unquestionably:
No one will escape death.
It would be good above all
To abandon evil and do good.

Genealogy from Richard II, Duke of Normandy (d. 1027) -
William the Conqueror, King of England 1066 -1087

PROLOGUE

Par ceste figure desus poet l'em saver les diverse regnes ke furent jadis en Engletere e si deit l'em saver qe Engletere est bien lunge. E par ceste figure puet l'em ausi saver coment les regnes furent asises, c'est a saver le quel est devers le est e le quel devers le west e le quel devers le no(r)th e le quel devers le suth. E pur ceo Engletere, qe fu jadis apelé Britaine pur le nun de un premer habitour ke avoit a noun Bruto, quant les geanz furent vencuz, e de tutes yles ceste est la plus benette. Car ele est asise entre le north e le west, de queus ele receit accitable (?) temperance, c'est a saver del west chalur e del north freidur.

La quele yle seint Gregore preisa mult quant il regarda a Rome trespassanz les enfanz d'Engletere que les marchans voleint vendre en marché si cum autre marchandie [e il] dit: 'Vreiment, bien sunt apelez Engleis, kar lur vout resemble a vout de angele.' E adecertes e en les jours que ore sunt l'om ne trove nule nacioun el munde que si curteisement n'en od si grant deuocioun serve Deu e Seinte Eglise.

Puis que les regnes ke sunt escriz desus en la figure furent departiz, les rois que adunk regnerent chescun en sa partie si comencerent a estriver entre eus, dekes les uns furent vencuz e les autres eurent la victorie. E furent les seet regions mis en cinc, issi que le premer roy regna tant soulement en Kent, sicum devant, sanz autre ajustement. Le secunde roy, c'est a sever de Westsexe, tient Surreie e les contrés de Suthamptone e de W[iltsire], Barksire, Somersete, Dorsete, Devenesire e Cornewaile. Si aveit ces eveskes: de Cicestre, de Wyncestre, de Salesbire et de Baa, que fu jadis a Welles, e le eveske de Excestre; e en liu de celi furent jadis dous, li un fu a Cridenton e ly au(t)re a Seint Germein. Le tiers roi, c'est a saver de Merchenerche, e avoit ces contrez: Gloucestre, He(r)ford, Wircestre, Salesbir, Cestre, Stanford, Derbi, Notingham, Leycestre, Nichole, Northamtone, Warwik, Oxenford, Bokingham, Huntindonn o la moyté de Bedeforde; e aveit ces eveskes: de Hereford, de Wircestre, de Coventre, que est dit de Cestre, e de Nichole. Le quart rei tient Estsexe, Middelsexe, Hertforde, Southfolk, Northfolk, Cantebrig e la moité de Bedeforde; e avoit treis eveskes: de Lundres, de Ely e de Stanforde, que ore est Norwis. Le quint rei, c'est a saver de Northumber, e avoit tute les cuntrez de outre Humber, si cum il piert desus en la figure.

Ore lessuns de ceo e des princes ke del (tens) as Brutons eurent seignurie par divers provinces, des quels nos reis natureus eurent nessance e comensun al noble guerreour Ethelbert, le fiz Emund, ke tient le regne de Westsexe e conquist vigorousement par bataille trestute la seignurie d'Engletere sur tuz les autres reis.

By the figure above, you can find out about the various kingdoms which once existed in England; you should know that England is very long. This figure also shows how the kingdoms were placed, i.e. which one is towards the East, and which one towards the West, which one towards the North and which one towards the South. For this reason England, which was once called Britain from the name of an early inhabitant called Bruto at the time when the Giants were defeated, is the most blessed of all isles, because it is situated between the North and the West from which it receives acceptable moderate temperature, getting warmth from the West and cold from the North.

Saint Gregory valued this island greatly when he saw the children of England, whom the merchants wanted to sell in the market like any other goods, passing by in Rome and said: 'Truly, they deserve the name of English, for their faces look like those of angels.'[1] And certainly nowadays, there is no nation in the world that serves God and the blessed Church in such a courtly manner or with such devotion.

After the kingdoms described above in the figure [of the Heptarchy] had been shared out, the kings who reigned at the time, each in his part, started to fight amongst themselves, until some were defeated and others were victorious; thus the seven regions became five. The first king reigned only in Kent as before, without any change. The second king, i.e. of Wessex, held Surrey and the counties of Hampshire and of Wiltshire, Berkshire, Somerset, Dorset, Devonshire and Cornwall; he had the following bishops: of Chichester, Winchester, Salisbury and Bath (who was formerly at Wells), and the bishop of Exeter (there were formerly two bishops in his place, one at Crediton and another at Saint Germans). The third king, namely that of Mercia, held these counties: Gloucestershire, Herefordshire, Worcestershire, Shropshire, Cheshire, Staffordshire, Derbyshire, Nottinghamshire, Leicestershire, Lincolnshire, Northamptonshire, Warwickshire, Oxfordshire, Buckinghamshire, Huntingdonshire and half of Bedfordshire; and he had these bishops: of Hereford, Worcester, Coventry (who is called bishop of Chester) and of Lincoln. The fourth king held Essex, Middlesex, Hertford, Suffolk, Norfolk, Cambridgeshire and half of Bedfordshire, and he had three bishops: of London, of Ely and of Stanford[2] which is now Norwich. The fifth king, that of Northumbria, had all the counties beyond the Humber as it appears above in the figure.

Now, let us leave this matter and the princes who from the time of the Britons had lordship throughout various provinces, from whom our native kings sprang, and let us start with the noble warrior Ethelbert [Egbert], the son of Edmund, who held the kingdom of Wessex and vigorously conquered in battle the entire lordship of England from all the other kings.

1 Famous pun, in Latin, comparing 'Angli' (Angles, English) with 'angeli' (angels).
2 Error: the see of Norwich was previously based at Elmham (and then briefly Thetford, which might have been incorrectly interpreted as 'Stanford').

EGBERT (829-839)

[THE FIRST KING OF ENGLAND; HIS ENTRY IS TOWARDS THE END OF THE PROLOGUE]

Icestui Ethelberd, le fiz Emund, fu nee e nori en Westsexe, ki comensa estre vaillant e pruz bacheler. Mes ly roy Brithrich, que adunk regna en Westsexe, aveit envie envers ly, si li vout tuer pur ceo que il doteit que cesti Ethelbert ly toleit la reaume. Dunt cely Ethelbert, quant il aparceust cele fraude, si s'enfui en France, ou il aprist bones custumes e curteisies e la haunt des armes. E en cel tens le roy Charlemaine le Grant avoit regné en France XXXIIII anz e aprés il regna XII anz, les ques asemble joinz sunt XLVI anz. E ileck demora Ethelbert jekes Brithrich fu mort. E puis aprés, les Westsaxoneis enveierent quere l'evaundit Ethelbert e ly firent roy, li quel se conseilla cum prus e sages a ses barons e meintent sun regne e sun host e tint guere encontre les autres petiz rois XVIII anz, les ques complis il regna treis ans en pes. E trestut le tens que il regna amounte XXXVII anz e VI mois e puys morust e fu teré a Wincestre.

This Ethelbert [sic], son of Edmund, was born and bred in Wessex. He began by being a valiant and worthy young man. But King Brithrich [Beorhtric], who then reigned in Wessex, had resentment against him. Thus he wanted to kill him because he feared that this Ethelbert would take the kingdom from him. This Ethelbert, when he realised this deception, fled to France where he learnt good customs and courtliness, and training in arms. At this time, King Charlemagne the Great had reigned in France for thirty four years, and he was to reign another twelve years, which together make forty six years. Ethelbert dwelt there until the death of Brithrich. Then the people of West Sussex sent for the aforesaid Ethelbert and made him king. He took counsel as a worthy and wise man from his barons; he maintained his kingdom and his army, and warred against the other little kings for eighteen years, after which he reigned three years in peace. The total time he reigned comes to thirty seven years and six months. Then he died and was buried in Winchester.

ETHELRED (866-871)

Icestui Ethelred fu bon home quant a Deu e pruz e vaillant quant al secle. Il regna aprés son frere Ethelberd. Les paiens assaillerent cestui si egrement que IX foiz dedens quatre anz il ly donerent bataille champestre, hors pris autres assaus. E nequedent il venqui sovent ses enemis e relement vencu. Il prist un batalle que deit bien estre en memoire sur Asseldoune encontre le roi Osek de Denemarche que li vint a l'encontre ovekes dous rois e ovekes cinc countes e ovekes grant host sanz numbre. E celi Osek avoit sun host devisé en dous parties: le une partie fu laissé as rois e l'autre a countes. E li roi Ethelred ala encontre les rois, prist ausi la meité de sun host a ly, e l'autre moyté lessa a sun frere Alured encontre les cuntes e les barons. E quant il urent tut le jour cumbatu, si se reposerent au seir. Le matin, tant cum li rois Ethelred oi sa messe, sun frere Alured ala hastivement a la bataille od sun host e les Daneis lur vindrent vigerousement a l'encontre que les Engleis furent si esbai que a poi k'il ne s'en returnerent en fuite. Pur la quele chose il enveierent pur le roi. Mes il ne vout isser du muster je(ske) la messe fut dite. E, quant ele fut dite, si se comanda a Deu e prist ses armes. E quant il vint a la bataille, il se seigna del signe de la seinte croiz e descumfit noblement ses adversaires e persa le fort hauberc al rei Osek e le feri de sa launce parmi le cors e si tua un autre roi par coup d'espeie e meint autre k'il occist de sa main. E si morurent les cink cuntes avant dites e tute la multitude des autres que la avoient. Allas ! il ne vesqui fors un poi aprés e ce fu grant damage si Deu le oust volu. Si ne regna fors soulement cinc anz e morust e fu enteré a Winburne.

This Ethelred was a good man concerning God, and brave and valiant concerning the world. He reigned after his brother Ethelbert. The pagans assaulted him so bitterly that nine times in four years they gave him open battle, as well as other attacks. Nevertheless, he often vanquished his enemies and was rarely beaten. He had a battle which ought to be remembered at Ashdown against king Osek [Bagsecg] of Denmark, who came against him with two kings, five earls and a great army without number. This Osek had divided his army into two parts: one was given to the kings, the other to the earls. King Ethelred went against the kings, and took half his army with him, and left the other half to his brother Alfred [the Great] to go against the earls and the barons. After they had fought all day, they rested in the evening. In the morning, while King Ethelred was hearing Mass, his brother Alfred went hastily into battle with his army; the Danes fought them so vigorously that the English were striken with terror and close to retreat. Therefore they sent to the king, but he refused to leave the church until Mass had been said; when it was complete, he commended himself to God and took up his arms. When he joined the battle, he signed himself with the sign of the blessed cross and nobly vanquished his adversaries. He pierced the strong hauberk of King Osek and wounded him with his lance through the body. He killed another king with a blow of his sword, and killed many more by his hand. The five earls mentioned above died, as well as the rest of the multitude which was there. Alas, he only lived for a short while afterwards, which was a great pity, if God would have willed it. Thus he only reigned for five years, then died and was buried at Wimborne.

ALFLED [ETHELFLEDA]

Icesti Alfled estoit la plus sage de tute femmes seculers, dunt par sun sen e par sun savoir ele eida mult sun frere Edward a governer le reaume. Iceste, quant ele fu marié au cunte Edrid e que sun pere li avoit doné, si enfaunt un fiz. E james aprés ele ne suffri ke sun seignour cochast od li charnelment car ele dit que ligne de reine ne devoit mie user ne amer tu fou delit, ou taunt avoit angoisse en enfantaunt.

This Alfled was the most wise of all lay women. With her intelligence and her knowledge, she greatly helped her brother Edward to govern the kingdom. When she was married to earl Edrid [Ethelred] to whom her father had given her, she bore him a son; thereafter, she never allowed her lord to sleep with her carnally, for she said that the lineage of queens should not practise or love sensuality where there was such suffering in giving birth.

ATHELSTAN (924-939)

Icesti Athelstan, le fiz Edward le Veil, regna aprés sun pere. Il fu le plus bel home que adunk estoit. Allas ! il vesqui pou. Mes il ne fu pas pou redoté, car il fu plusur feez lassé en bataille mes jamés ne pout estre vencu. E si avoit si noble corage que il (ne) fina de cumbatre jeskes a tant q'il mist le prince de Galeis e le rei d'Escoce en truage, issi que il prist trestouz les anz vint livres de or et treis cenz livres de argent e vint boefs. E tut fut il home bataillous, neqedent il fesoit fere plusurs mosters. Cesti avoi une soeur tresbele que avoit anoun Edrid, la quele Hue, le roi de France, demanda a femme, pur qi amur il enveia au roi Athelstan precious douns, c'est a saver chevaus covers des armes e piers preciouses de chescune manere e l'espei a l'emperour Costantyn e un des treis clous au sauveour e la launce e la banere seint Morice; e si l'enveia de la crois Nostre Seignur e de la corone des espines e un crois aurné des pieres preciouses. Les queus reliks resceuz li roi e li envoia sa soeur. Si regna noblement vint e sis anz e morust e fu enteré a Malmesburi.

This Athelstan, son of Edward the Elder, reigned after his father. He was the most handsome man that ever was. Alas, he did not live long. But he was greatly feared, because although he became tired several times in battle, he could never be beaten. And thus he had such noble courage that he did not cease to fight until he made the prince of Wales and the king of Scotland pay tribute to him, so that every year he collected twenty pounds of gold, three hundred pounds of silver and twenty oxen. Although he was a warlike man, he nevertheless founded several monasteries. He had a very beautiful sister who was called Edrid [Eadhild], whose hand Hugh the king of France[3] asked for in marriage. For love of her, he sent to King Athelstan some precious gifts, such as horses covered in arms and precious stones in every way, the sword of Emperor Constantine, one of the three nails of the Saviour, and the lance and the banner of Saint Maurice. He also sent him part of the cross of our Lord, part of the crown of thorns, and a cross adorned with precious stones. The king received these relics and sent him his sister. Thus he reigned nobly for twenty six years, died and was buried at Malmesbury.

EDWY (955-959)

Icesti Edwyn, le fiz Emun, regna aprés Edrid e tint le reaume quatre anz. Icesti fu malveis e luxurious e malment se demeneit vers Deu e tute gent. Aprés sa mort, si cum les deables le tirerent a turment, un deable nuncia a seint Donstan de sun persecutur e il chei meintenant en lermes e pria si lungement Jhesu Crist, funtaine de misericorde, jeskes il fu delivré des deables e que il avoit remission par ses prieres. E tant cum il regna, Seinte Eglise fu ledie e cheitive. Icesti Edwine fu tre bele home, i(l) toli a un grant seignur sa femme pur beauté de ly, e neqedent memes cele femme fu sa cosine. E cely memes guerreout Seinte Eglisze, e nomeement seint Dunstan. E, puis que il out regné quatre anz, morust e fu enteré a Wincestre.

This Edwin, son of Edmund, reigned after Edred and held the kingdom for four years. He was bad and lustful, and behaved badly towards God and all people. After his death, while the devils dragged him towards torment, a devil announced the fate of his persecutor to Saint Dunstan; he immediately burst into tears and prayed at such great length to Jesus Christ, fount of mercy, that he [Edwin] was delivered from the devils and given remission through his prayers. During his reign, the blessed Church was abused and wretched. This Edwin was a very handsome man. He took a great lord's wife from him for her beauty, despite her being his cousin. He fought against the blessed Church and particularly Saint Dunstan. He died after a four-year reign, and was buried in Winchester.

3 This Hugh was actually count Hugues le Grand, father of King Hugues Capet.

EDWARD THE MARTYR (975-978)

Icesti Edward regna aprés sun pere Edgar e tint sun regne treis anz e demi par sun poer encontre la volunté de sa marestre, que avoit a noun Estrild, dunt ele se coruça e ne fina aparailler engins a son feillastre. E si cum cestui Edward venoit de chacer un jour, trestut laas, e ses chevalers furent desparpelez par la pleine, il passa par devant la meison sa marastre. Et cele par sa blandisemenz le fist attendre a ly e le beisa par traison e li tendi a beivre e tant cum il beust ele ly nafra hu cors. E cil se sent que il fu cruelement turmenté si se returna a sa genz a quant k'il peust; et quant il les trova, moustra les signes de sa mort de sanc que curreit par ses peez e par le chemin. Il regna treis anz e demi et morust e fu enteré a Chaftesburi.

This Edward reigned after his father Edgar. He held his kingdom for three and a half years through his own power against the wishes of his step-mother who was called Estrild [Elfrida/ Elstrudis]. She got angry at this, and never ceased to plot against her step-son. One day, as Edward had been hunting completely weary, and his knights had got spread out around the plain, he passed in front of the house of his step-mother. She with various blandishments made him remain there; she gave him a treacherous kiss and a drink. As he was drinking, she wounded his body. He realised that he was cruelly hurt, and thus returned to his followers as far as he could. When he found them, he showed the signs of his death from the blood that was running to his feet and on the road. He reigned three and a half years, died and was buried in Shaftesbury.

ETHELRED THE UNREADY (978-1013 AND 1014-1015)

Icesti Ethelred, le fiz Edgar, comenca a regner aprés la mort sun pere [sic], que fu cruelment occis. De cestui propheta seint Donestan quant il li baptiza pur ceo que il pissa en funz e dit: 'De curs de lui cruel serra al comensement, e cheitif en mileu e tres malveis e malerous en la fin.' Et dis anz aprés que seint Dunstan vesqui, il regna en pes. E aprés sun decés, les Daneis vindrent tuz les anz wastant la tere e assaillanz le roi par la treison Edrit, counte de Saropesburi, que tuz jours mustreit le conseil le roi a ses enmis. Certes il fu tres mauveis treitre e ceo lui aparust en sa fin. E cestui Ethelred e(n)gendra Emun Yreneside de sa premer femme e si engendra Alured que fu trai par Godwin, counte de Kent, e Edward le Confessour, que gist a Wemuster, de la fille Richard sanz Pour, duc de Normundie. Il regna trente e seet anz e morust e fu enteré a Lundres, a Seint Pol.

This Ethelred, son of Edgar, started reigning after the death of his father[4] who had been cruelly murdered. Saint Dunstan made a prophecy about him when he baptised him, because he peed in the font: 'His course will be cruel at the beginning, wretched later on, and very evil and hurtful at the end.' During the following ten years, while Saint Dunstan lived, he reigned in peace. After his death, the Danes came every year, wasting the land and attacking the king through the treachery of Edric the earl of Shropshire, who every day told the enemy of the king's decisions. Indeed, he was a very evil traitor and this appeared to him at his end. This Ethelred fathered Edmund Ironside by his first wife, and he also fathered Alfred who was betrayed by Godwin, earl of Kent, and Edward the Confessor who lies in Westminster, by the daughter of Richard the Fearless, duke of Normandy. He reigned for thirty seven years, died and was buried in London, at Saint Paul's.

MARGARET, QUEEN OF SCOTLAND AND MAUD, QUEEN OF ENGLAND

Iceste Margarete fu fille Edward, le fiz Emun Yreneside de Engletere, qui ariva en Escoce par la force des venz deskes la chacerent par cas en la mer. La quele le roi d'Escoce Maltot [sic] prist a femme, de la quele il engendra une fille qui out a noun Maud, la quele le premer roy Henri de Engletere esposa aprés (engendra) une fille resemblable a la mere de vertuz e de renoun, si cum il parra aprés la ou ele estoit esposé au roy.

This Margaret was the daughter of Edward, the son of Edmund Ironside of England, who arrived in Scotland due to high winds which up to there chased randomly at sea, and whom the king of Scotland Malcolm took to wife. From her, he fathered a daughter who was called Maud, whom the first king Henry of England married. Afterwards[5] was born a daughter resembling her mother in virtue and fame, as will appear later, in the place where she was married to the king.

4 Error: the scribe has copied 'pere' (father) instead of 'frere' (brother).
5 Despite this conjunction, the sentence probably still refers to Maud/Mathilda, the wife of Henry I.

Meridies

Zephyr̄ʾ
ſeptentrō
lis.

Oriens

elle
nr
ꝛ bien.
toute rien.
ſmez ozgoū.

KNUT
(1016-1035)

Quant Swein, le roy de Denemarche, fu mort e porté en Denemarche, le roy Ethelred, que fu en Normundie, le oi dire, si vint en Engletere e tint grant feste a Lundres. E le jour de sa feste, si cum acune gent dient, ariva le rey Knout a grant poer e asega le roy Ethelred en Loundres, en corant le sege avant dite Ethelred morust. E Knout prist la reyne Emme e l'esposa e engendra de lui Hardeknout que puis fu roy de Denemarche e d'Engletere. Emoun Yreneside asembla grant poer des Engleis e sovent se combati a Knout. Au derein se acorderent e partirent la tere entre eus e se entrejurerent de tener pes entre eus e amisté. Puis morust Emoun Yreneside e aprés ly avoit Knout en Engletere grant poer kar il fu seignur de Denemarche e de Norwei e d'Escoce e de Engletere aprés Emoun Yreneside. Dedenz le premer an de sun corounement, tuz ceus ceus qui aveient tué le roy Emoun par la voerie de Edrich le traitour si vindrent a ly en esperance de estre noblement reguerdonez du roy Knout. E li rei fit asembler sun barnage e devant tuz fu la traison reconue e pur Knout les fit trestuz morir de vileine mort.

When Svein, king of Denmark, died and was carried to Denmark, King Ethelred, who was in Normandy, heard about it, and thus came to England and held a great feast in London. And on the day of his feast, as some say, King Knut arrived with a large force and besieged King Ethelred in London; whilst this siege took its course, Ethelred died. Knut took Queen Emma and married her, and begat from her Hardeknut who was later king of Denmark and England. Edmund Ironside assembled a great force of Englishmen, and often fought Knut. Finally they came to an agreement, they shared the land between themselves, and they swore to each other to keep peace and friendship between them. Then Edmund Ironside died; after which, Knut had great power in England, because he was lord of Denmark, Norway, Scotland and England after Edmund Ironside. Within the first year of his coronation, all those who had killed King Edmund by the authority of Edric the traitor came to him in the hope of being nobly rewarded by King Knut. The king assembled his baronage, and the treachery was acknowledged before all. For this Knut had them all die a shameful death.

ST EDWARD
THE CONFESSOR
(1042-1066)

En le an de grace M°C°XL deus mois [sic], Edward, le fiz Ethelred le roy, fu repelé de Normundie, ou il estoit nori, e il regna aprés les Daneis si cum droit eir. Icesti, par la force des Daneis Engleis prist a femme la fille Godwin, le fort counte de Kent, que fu la soer Haraud, en esperance du ligne que fut a venir. E nequedent il ne a la doucha [sic] mie charneaument car il demora virgine. Icesti Edward repela de Hungrie ses nevous e ses neces, c'est a savoir Edrich [sic] Etheling, que il ama especiaument e desireit que il fust sun eir e successour del reaume. E li pesible Edward regna XXIIII anz e VI mois e XX iours e si trespassa de ceste vie au regne celestre la veile de la Typhaine. […]

In the year of grace 1140 [sic] and two months, Edward, son of King Ethelred, was recalled from Normandy where he had been brought up. He reigned after the Danes as the rightful heir. By the power of the English Danes [sic], he took as his wife the daughter of Godwin, the powerful earl of Kent, who was the sister of Harold, in the hope of a lineage to come. Nevertheless, he never touched her carnally and remained a virgin. This Edward recalled from Hungary his nephews and nieces, i.e. Edrich [Edward] Atheling whom he loved in particular and wished to see as his heir and successor to the kingdom. The peaceful Edward reigned for twenty four years, six months and twenty days, and departed from this life to the heavenly kingdom on the eve of Epiphany. [...]

WILLIAM RUFUS
(1087-1100)

En le an de grace M utante e setime, Willem le roy regna aprés sun pere. Icesti ala chacer en la Novele Forest e fut espié de Wauter Tyrel, si feru de un seete e morust. Il feseit tuz jours le mal quanque il pout. Il estoit malveis a estranges e pire as seons e treis malerous a ly mesmes. Tutes les choses que pleisent a Deu, si despleiseient a li. Il morust e fu enteré a Wincestre. El tens a celi roy, seint Anselme fu despoillé de tuz ses biens e si fu exilé deskes en la fin de cesti roy Willeme. E seint Wlston, que fu eveske de Wircestre e home de seint vie, trespassa gloriousement de ceste siecle en la joy pardurable.

In the year of grace 1087, King William reigned after his father. He went to hunt in the New Forest; he was spied upon by Walter Tirel, wounded by an arrow, and died. He committed every day as much evil as he could. He was bad towards strangers, worse towards those close to him, and three times as hurtful towards himself. All the things that please God displeased him. He died and was buried in Winchester. During the time of this king, Saint Anselm was despoiled of all his goods and was exiled until the end of this King William. Saint Wulfstan, who was bishop of Worcester and a man of blessed life, passed gloriously from this world to eternal joy.

HENRY II FITZEMPRESS, COURT MANTEL, OR PLANTAGENET (1154-1189)

Icesti Henri le secunde fu fiz Maud l'emperice, que fu fille a premer roi Henri e a Maud, la fille le roy d'Escoce e a seinte Margarete, que fu file Edgar Etheling, le fiz Emoun Yreneside, que fu fiz au roy Ethelred, le fiz Edgar le Peisible. E en tele manere poet home numbrer le linage a cesti Henri tuz jours movertant[6] deskes a premer home.

Icesti Henri, duc de Normundie, oiant noveles par certein messager de la mort Estevene, si vint en Engletere e fu resçu curteisement de la clergie e a grant ensemble del poeple e fu corouné cum roy de Thebaud, erceveske de Canterbyres, le dymeine de le XIIII kalende de jenever, a Westmouster. E il prist en sa main tuz les citez e les chasteus e totes les choses que apartienent a la coroune e fist mettre (hors) du reaume tuz les aliens. E el tens que Thomas, ercedeakne de Canterburi, fu fet chanceler del regne e erceveske de Canterburi. Cestui Henri, puis que il out regné XXX anz e X mois, si morust en le an de grace M e C LXXX neofime, auz utaves de Seint Peree e Sein Poel e fu enteré a Pount Everaud [sic]. E en tens cely Henri fu seint Thomas martirizé.

This Henry the second was son of Maud the empress, who was the daughter of the first King Henry and of Maud, daughter of the king of Scotland and of Saint Margaret, who was daughter of Edgar [Edward] Atheling, son of Edmund Ironside, who was the son of King Ethelred, the son of Edgar the Peaceable. In this manner, one can always follow the lineage of this Henry right up to the first man.

This Henry, duke of Normandy, having heard from a messenger the news of Stephen's death, therefore came to England and was received honourably by the clergy and by the people as a whole. He was crowned king by Theobald, archbishop of Canterbury, the Sunday of the fourteenth Kalends of January in Westminster. He took in his hands all the cities and castles and all things which belong to the crown, and he ejected from the kingdom all the aliens. It was the time when Thomas archdeacon of Canterbury was made chancellor of the kingdom and archbishop of Canterbury. This Henry, after a reign of thirty years and ten months, died in the year of grace 1189, at the octaves of Saint Peter and Saint Paul, and was buried in Fontevrault. During the time of this Henry, Saint Thomas was martyred.

HENRY III (1216-1272)

Cesti Henri le tierz regna aprés sun pere Johan. Icesti Henri est dit le tierce pur ceo que il (est) entitlé en cronicles e en esccriz, ne mie pur la reson del noun mes pur la reson de real seignorie. Car si le premer roy Henri, le fiz al conquerour, seit contee, e puis Henri le fiz a l'empire [sic], aprés le fiz a cely Henri que fu dit Henri le Juvene Rey, sanz doute icesti serreit le quarte Henri. Mes pur ceo que cely Henri que fu dit le Juvene Rei ne regna mie, car il morust avant sun pere[7]. Icesti Henri, dedens le dime an de sun age, le jour Seint Symoun e Jude, si fu corouné a grant joye. A quel corourment il jura k'il portereit honour e pes e reverence a Deu e a Seinte Eglise e a ses ordeniers, e ceo fist il noblement. Icestui commença la novele eovre a Wemuster a l'honur de Deu e de Seint Pere e de Seint Edward. En sun tens fu la guere en Engletere entre le roy e les barons e la bataille de Lewes feri en le an de grace M e CC e LX e quatre mois [sic], e aprés, en l'an siwant, Symoun de Mountfort fu occis a la bataille de Evesham. E quant il out regné LXI anz [sic], il trespassa de ceste secle en l'an de grace M e CC e LXXII e fu enteré a Wesmouster.

This Henry III reigned after his father John. This Henry is called the Third; this is how he is named in chronicles and in writings, not because of his name but because of his royal lordship. For if one counts the first King Henry, the Conqueror's son, then Henry FitzEmpress, and afterwards this Henry's son who was called Henry the Young King, no doubt this Henry would be the fourth Henry. But because the Henry who was known as the Young King did not reign, since he died before his father.[8] This Henry, in the tenth year of his life, the day of Saints Simon and Jude, was crowned amid great joy. At his coronation, he swore that he would bring honour, peace and reverence to God, to the blessed Church and to its officials; this he did nobly. He started the new works at Westminster in the honour of God, Saint Peter and Saint Edward. In his time, there was war in England between the king and the barons. The battle of Lewes raged in the year of grace 1260 and four months; then the following year, Simon de Montfort was killed at the battle of Evesham. After having reigned sixty one years, he left this world in the year of grace 1272 and was buried in Westminster.

6 Misread by scribe; should read 'mountant'.
7 End of sentence missing.

8 End of sentence missing. Reconstituted from the texts of similar rolls, it would read roughly as follows: 'therefore, taking into account those who actually reigned, this Henry is called the Third.'

THOMAS OF LANCASTER	Cestui Thomas fut counte de Lancastre e de Leycestre e seneschal d'Engletere. E si fut counte de Derby e par la contesse Aleyse, sa compaigne, il fut counte de Nicol e de Saleburi.	This Thomas was earl of Lancaster and Leicester, and seneschal of England. He was also earl of Derby, and through his wife the countess Alice, he was earl of Lincoln and Salisbury.
EDWARD I (1272-1307)	Cestui Edward en sa juvente, quant primes fut fet chevaler, ala turneer en totes terres par la crestienté e pus ala oveke VII[xx] chivalers en la Terre Seynte e la demora III aunz e demy, e Elianore sa regne ovekes luy. E la fut il sovent en meynte mortele bataile countre les sarazyns. E dunke luy vint novele que son pere, le roy Henri, fut a Deu comaundé E pur ceo prist tru oveke le soudan tanke III aunz e retorna en Engletere e fut corouné rey d'Engletere. E pus avoyt taunt a fere tote sa vie contre Galeys, Escoceys e pus countre le roy de Fraunce pur Gascoyne, que retorner ne poeit en la Terre Seynte. Cestui Roy Edward regna XXXIIII aunz e IX mois e venquist touz ses enemys e conquist Gales, Escoce e Gascoyne. E en touz ses fes fut dreiturel e de grant misericord e fut enterré (a) Weymouster.	This Edward, in his youth, when he was first made a knight, went jousting in all lands within Christendom. Then he went with 140 knights to the Holy Land and remained there for three and a half years, with Eleanor his queen. There he was often engaged in numerous mortal battles against the Saracens; then he received the news that King Henry his father had been commended to God. Therefore he negotiated a truce with the sultan for three years, returned to England and was crowned king of England. He had so much to do all his life against the Welsh, the Scots, and then against the king of France about Gascony, that he could not return to the Holy Land. This King Edward reigned for thirty four years and nine months, vanquished all his enemies and conquered Wales, Scotland and Gascony. In all his actions he was just and very merciful. He was buried in Westminster.
LIST OF THE CHILDREN OF EDWARD I	Fet a saver que des enfaunz le bon roy Edward par desus purtrez, Johan de Wyndesore, sun primer fiz, morust tost et Henri de Wyndesore auxi. Elianore fut contesse de Bare. Margarete fut duchesse de Breibaunt. Johane de Acre fut countesse de Gloucestre. Elianore fut contesse de Heplaunde e pus fut esposé al counte de Herford e de Esex. Marie fut noneyne a Aumbersbirri. Anfouns de Bayone morust a Wyndesore. Edward regna aprés sun père. Thomas fut counte de Sufolk e de Northfolke e mareschal d'Engletere. Edmund de Wodestoke fut counte de Kent.	It should be known that of the children of good King Edward represented above, John of Windsor his first son died early, as did Henry of Windsor. Eleanor was countess of Bar, Margaret was duchess of Brabant, Joan of Acre was countess of Gloucester, Eleanor [Elizabeth] was countess of Holland and then married the earl of Hertford and Essex, Mary was a nun at Amesbury, Alfonso of Bayonne died in Windsor, Edward reigned after his father; Thomas was earl of Suffolk and of Norfolk and marshal of England, Edmund of Woodstock was earl of Kent.
EDWARD III (1327-1377)	Edward le tierz. Et il avait issu Edward le prynce, Leonell, Johan de Gaunt, Edmund de Langle et Thomas de Wodestok. Et de Edward le Prynce vient le roy Richard secunde, que regna XXI aanz e le tiers an comensant. Et puis morust sanz heir. Et donque vient Henri le quart, fiz de dit Johan de Gaunt.	Edward the third. He fathered Edward the prince, Lionel, John of Gaunt, Edward of Langley and Thomas of Woodstock[9] From Edward the prince came King Richard the second who reigned for twenty one years, and the third year[10] starting [sic]. Then he died without heir[11]. And therefore came Henry the fourth, son of the said John of Gaunt.

9 'Wodestok' added above the line.
10 'an' added above the line.
11 'sanz heir' added above the line.

Edward II (1307-1327).

Edward

DESIGN AND PRODUCTION
Peter Keenan EN3

PHOTOGRAPHY
Matt Pia

Printed in the UK by
BAS Printers

ISBN 0-9549014-1-X
Copyright 2005
Sam Fogg, London

Picture Credits
Figs. 2, 7, 11, 14 and 15: reproduced by permission of the British Library Board.
Figs. 19 and 22: reproduced by permission of Cambridge University Library.
Fig. 27: reproduced by permission of the Bodleian Library, University of Oxford.